# Wildlife

## PAINTING BASICS

# WATERFOWL & WADING BIRDS

*"He who knows nothing of Nature, who fails to see and appreciate her beauty, is as one*
*who passes through a great art gallery where all the pictures are turned to the wall."*

—Thomas H. Huxley

# Wildlife
## PAINTING BASICS
## WATERFOWL & WADING BIRDS

Rod Lawrence

**NORTH LIGHT BOOKS**
CINCINNATI, OHIO
www.nlbooks.com

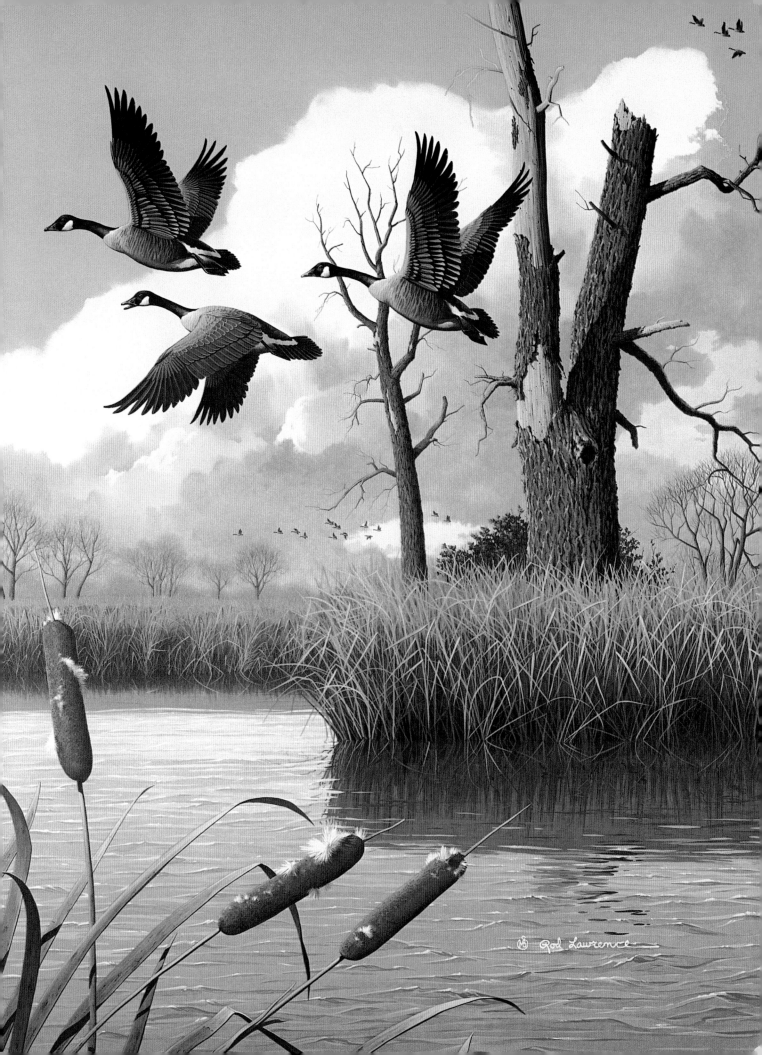

Rod Lawrence

## ACKNOWLEDGMENTS

I would like to thank North Light Books for another opportunity to share my work with other artists and collectors. I have worked with a number of people there. All have been warm and generous with their help, and I extend my thanks to each of you. In particular, I would like to thank Rachel Wolf, who was my first contact with North Light Books and began our association as the editor on my first book, *Painting Wildlife Textures*. For this book, I would like to thank Jennifer Lepore Kardux, my editor. I have tried her patience—and it was great! In the midst of it all, she got married, as if I was not trying enough! Congratulations and thank you.

I would also like to express my appreciation to all the people who have called, written and e-mailed me with their kind comments regarding my work and my first book. I truly appreciate your interest and support of my work.

## DEDICATION

*To my wife, Susan.*

To all those artists who find their inspiration in nature. Through their creative efforts, they discover new treasures and seek to share them with others who might otherwise have missed this enrichment of their lives through the natural world around us.

Other fine North Light Books are available from your local bookstore, art supply store or direct from the publisher.

04  03  02  01  00      5  4  3  2  1

Library of Congress Cataloging-in-Publication Data

Lawrence, Rod.
    Wildlife painting basics: waterfowl & wading birds/Rod Lawrence.
        p. cm.
    Includes index.
    ISBN 1-58180-022-3 (alk.paper)
    1. Wildlife painting—Technique. 2. Water birds in art. I. Title: Waterfowl & wading birds. II. Title.

ND1380.L383 2000
751.45'4328176—dc21                                                    00-055901

Art on page 3: *Canadas and Cattails*, Gouache on illustration board, 25" × 20" (64cm × 51cm), Private collection

Editor: Jennifer Lepore Kardux
Designer: Brian Roeth
Cover Designer: Amber Traven
Interior Production: Tari Sasser
Production Coordinator: Kristen D. Heller

Rod Lawrence graduated with a fine arts degree, magna cum laude, from the University of Michigan in 1973. Since then he has been working full time as a professional artist. His credits include being named the Michigan Ducks Unlimited Artist of the Year in 1979 and the Michigan United Conservation Club's Michigan Wildlife Artist of the Year in 1981. He also had the winning designs for the 1983 and 1990 Michigan Duck Stamps, and the 1981, 1987 and 1992 Michigan Trout Stamps. He had an unprecedented double win for both the 1995 Michigan Duck Stamp and the 1995 Michigan Trout Stamp. His win for the 2000 Michigan Duck Stamp makes him the only artist to have won eight Michigan stamps. He is one of only two artists to win four Michigan Duck Stamps and one of only two artists to win four Michigan Trout Stamps.

Lawrence has exhibited in many group and one-man shows, including the prestigious Leigh Yawkey Woodson Art Museum's "Birds in Art" and "Wildlife: The Artist's View" shows.

From these shows, his work has been chosen several times for national tours.

His art has also appeared as covers, illustrations and features in many outdoor magazines. Three sets of limited edition collector plates also feature his work.

Lawrence is an active instructor for wildlife art workshops. An instructional book, *Painting Wildlife Textures*, written and illustrated by Lawrence, was published and released by North Light Books in March of 1997.

A log cabin in the hardwood of northern Michigan, overlooking the north branch of the Manistee River, is home for Lawrence and his family. The symbol preceding his signature in each of his paintings shows the importance of his family in his work. The oddly shaped "S" is for his wife, Susan (an accomplished basket maker and instructor), and the "M" and "B" represent their sons, Matthew and Brett. For more information, you can contact Rod at his studio at 9320 M-72 South East, Kalkaska, Michigan 49646-9780, (616) 258-4724, or by e-mail at lawrence@gtii.com.

# table of contents

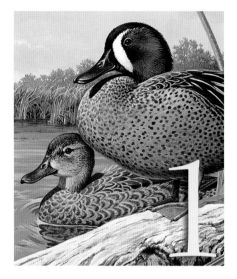

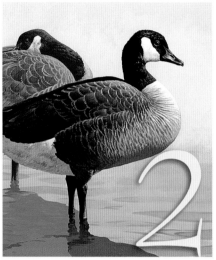

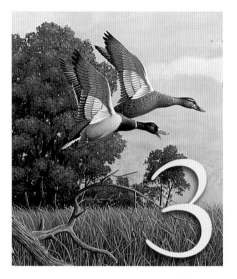

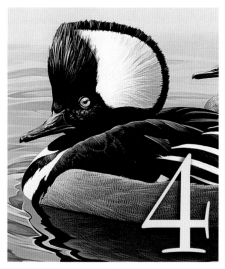

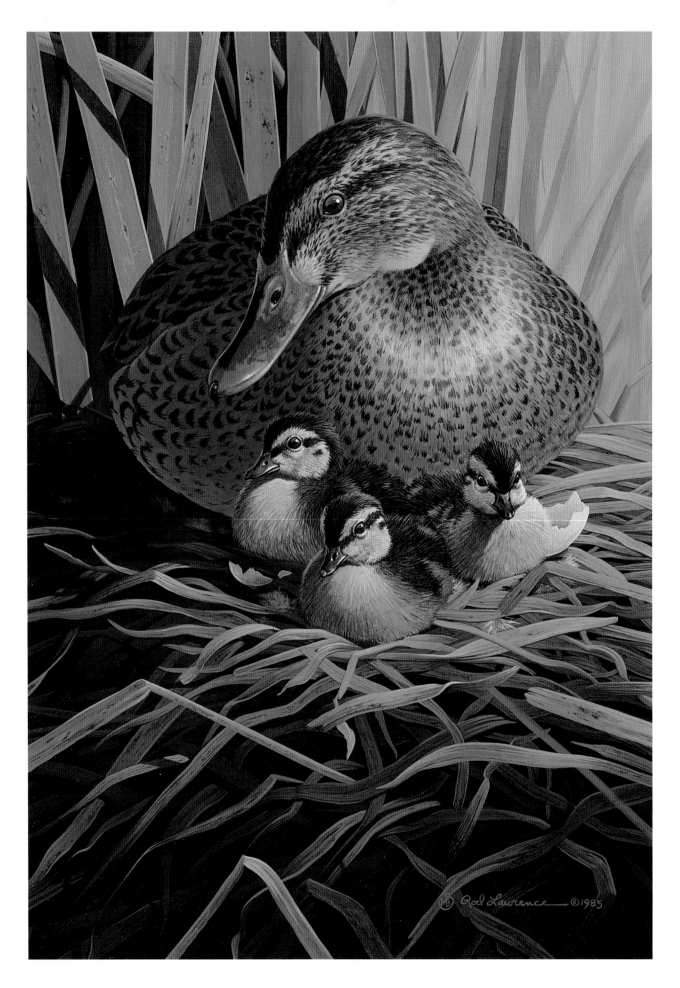

WATERFOWL & WADING BIRDS

# introduction

If you have an interest in wildlife, water birds in particular, then you have come to the right place! This book is intended to help you with your painting by giving you some tips, ideas and samples of how to paint these birds. The techniques and styles of painting in this book are not the only ways to work, they may not be the best way, and they may not be your way. However, I hope you will find the instruction encouraging, inspiring and most of all, that it will help you better express your love of nature in art.

Painting wildlife is fun. It requires a certain amount of knowledge about the subject and the ability to put that information into a painting. This is my way of expressing my love for these wild creatures and sharing it with others. It does not matter if you paint loose, bold, tight, impressionistic, realistic, or any other way your work might be described; you still have to know your subject matter. If you are going to correctly capture a creature by painting, be it with ten strokes or ten thousand, you still have to know what that creature is. You need to know its size, form, color, habits, behavior, the habitat it lives in and more. That process of studying the animal can be such a fun and learning experience. The more I research an animal, the more inspired I become. It is a major part of my

Layout drawing for *Spring Mallards*.

painting process and another part of the fun.

Waterfowl and wading birds are just a small and specialized part of wildlife painting. I sometimes think they require even more attention to paint because of their peculiar shapes and intricate patterns. The great thing about these creatures is they are readily available for you to study. Usually, there is a nearby body of water or local zoos where you can see a variety of these birds.

There are several important items to mention about painting these birds. I will cover some of what I feel are the most important in the first few chapters of this book. However, there are many aspects to painting, and far too many to cover them all here. Subjects like composition, painting styles, color theory and other art-related subjects can be full books on their own. I encourage you to study all these facets of art. You can learn so much from all the different artists and styles, and gain a greater appreciation for art overall. Best of all, it will help you with your own painting!

As a summary, allow me to point out what I feel are the key factors in painting birds, or any wildlife.

- Good drawing skills are very important to painting.
- Know your subject matter well.
- Take the time to study and research the species.
- Plan your painting.
- Paint as often as you can.
- Learn and improve with each painting you do.

Painting wildlife is fun, but it is also filled with frustration, hard work, exhilaration and dedication. Just like everyone else, I often face a painting or a subject and think to myself, "How the heck am I going to paint that?" I think each of my paintings go through a love/hate series of stages. The trick is to end the cycle with the love stage! Ready? Let's get started!

*Spring Mallards*
Acrylic on panel
13" × 9" (33cm × 23cm)
Collection of Heatherlee and Gregory Gosnick

# Materials

There are many mediums for painting. I prefer acrylic, but still enjoy using other mediums like oil and watercolor for the different challenges and effects that they offer. Whatever medium you use, there are some basic materials that you should have for painting.

## *Paints*

My own preference for paint changes a little from time to time. I have been quite pleased with both Grumbacher and Golden acrylics, but there are many other brands. Follow the manufacturer's guide and only use those colors that are rated highest for lightfastness and opacity.

My primary acrylic palette (at right) features my basic colors along with some I use less frequently. For my "black," I mix Ultramarine Blue, Burnt Umber and a dab of either Quinacridone Violet or Cadmium Barium Red Deep.

When I use watercolors, my basic palette is: Alizarin Crimson, Burnt Umber, Cadmium Orange, Cadmium Yellow Pale, Cerulean Blue, French Ultramarine, Winsor Green, Winsor Red and Yellow Ochre.

For oil painting my preferred palette is: Burnt Umber, Cadmium Barium Orange, Cadmium Yellow Light, Cadmium Barium Red Deep, Cerulean Blue, French Ultramarine Blue, Permanent Green Light, Titanium White and Yellow Ochre.

I mix my colors on a disposable palette manufactured by Utrecht. It is great for either acrylics or oil paints. It is nonabsorbent and does not buckle. On those rare occasions that I need a quantity of paint, I mix and save it in plastic 35mm film canisters. You can add water as needed and it will keep for quite a long time.

Throughout this book I mention a color value or hue, such as "red." This refers to a "red" hue or "red" value. Whatever "red" based color is listed in the materials list is the base "red" that I am referring to. You may choose to alter it with any or all of the other colors, depending on what pleases you.

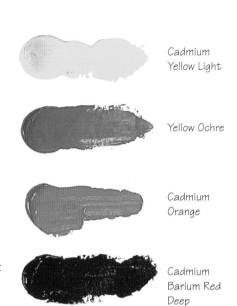
Cadmium Yellow Light

Yellow Ochre

Cadmium Orange

Cadmium Barium Red Deep

Quinacridone Violet

Permanent Green Light

Cerulean Blue

Ultramarine Blue

Burnt Umber

Payne's Gray

*My Primary Palette*
(Titanium White not shown.)

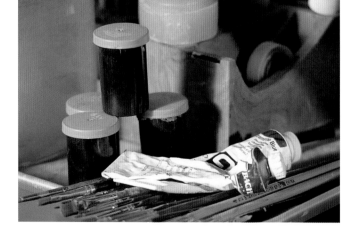

## Brushes

There are many shapes and sizes of brushes. The best ones are the ones that work best for you. I prefer rounds and some flats and brights. You don't have to spend a lot of money on brushes, but it is important to use those that hold a good edge or tip for painting. The rounds I use are usually numbers 2 to 3. The flats and brights I use are between ¼-inch (6mm) and 1-inch (25mm), sometimes bigger if I am painting a large area. I use cheap bristle brushes for mixing, as that is hard on the brushes and causes them to wear out quickly.

## Supports

Painting supports are numerous and varied. For acrylics I prefer a support called Solid Ground panels made by Hudson Highland in Kingston, New York. I like these panels because of their permanency and the effect the hard surface has when painting. They work well for building glazes. Occasionally, for acrylic, watercolor and gouache painting I use a good quality illustration board with an acid-free surface paper. I also like Arches and Strathmore watercolor papers. The Strathmore 500 Series bristol board is nice to work on as well. For oil painting, I prefer stretched linen.

## Studio Setup

I like to keep all my materials nearby. I have several drawing tables and easels, but do most of my painting on a slanted table. I keep my paint,

*My Studio Setup*

brushes and water on my left side. I also have a television, telephone and the remote for a sound system, as I occasionally like to have background distraction. My reference material is usually scattered around me in all directions.

Light is very important for painting. You need plenty of it so you can see clearly while you are working. I have my desk in front of a large window and have two strong lights right over my table. I have some color correct bulbs, but a typical incandescent bulb works well too. It is not good to use any bulb that gives an off color, such as the bluish color that some fluorescent lights produce.

*My Brushes*
These are some of my most commonly used brushes. They are (from right to left), a ¾-inch (19mm) flat sable, ⅜-inch (10mm) flat sable, no. 2 filbert bristle (for mixing), no. 6 round sable, no. 3 round sable and a no. 1 round sable. I use these for watercolor, acrylic and oil painting.

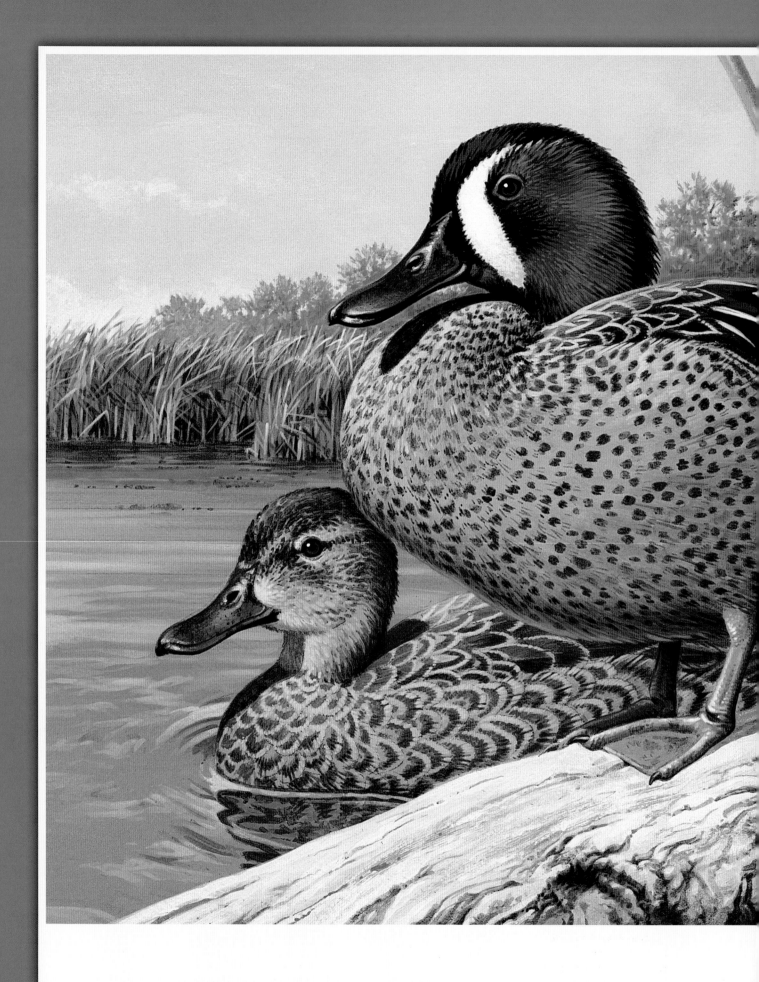

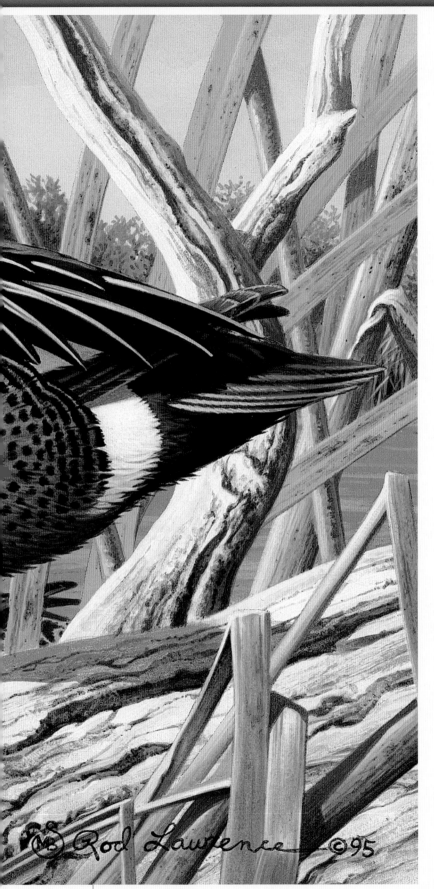

# 1

# GETTING STARTED

Starting is sometimes the hardest thing for an artist to do. And getting off to a good start is one of the most important things in painting. A good start involves planning the painting in the early stages. It is important and helpful to the painting process to have a good plan before you start to paint. That means you need a good idea of your composition, anatomy and color scheme. You should also have good knowledge of your subject matter, through research and quality reference material.

*Blue-Winged Teal* (1995 Michigan Waterfowl Stamp)
Acrylic on panel
7" × 10" (18cm × 25cm)
The Lang Collection

# Gathering Reference Materials

I have always believed that you paint (or draw) best what you know best. If you know and understand something, you are better equipped to portray it. If you have never seen a wood duck, how could you paint it? Would anyone even know what you painted? If you have seen a couple wood ducks either in the wild or at a zoo, you would have a much better idea of how to paint one so that someone might recognize it. Suppose you spent hours observing wood ducks, studying them, photographing them and sketching them? Think of how much more prepared you would be to do that painting now.

Good knowledge and reference material about your subject matter is crucial. Both will be apparent in your painting. People often ask me, "Do you paint from photographs?" I use anything I can get my hands on! That means such things as mounted birds, skins, dead birds, sketches, decoys, carvings and yes, photographs. I rely more heavily on my own photographs, but use others for detail and color reference.

These decoy heads are good reference for basic eider head shapes. They can be painted for more realism. These and other species are available from Lock Stock & Barrel, Inc., (810) 790-2678. The heads shown here are (top to bottom) the surf scoter, white-winged scoter, king eider and common eider.

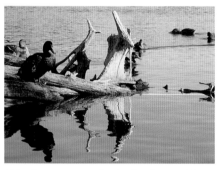

This photo captures the details of a wood log, and the gentle reflections of moving water.

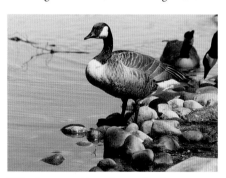

This photo provides reference for the goose itself, as well as its habitat.

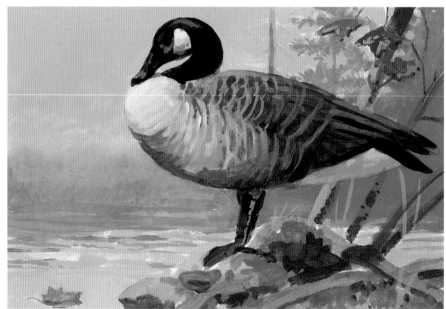

I changed the position of this goose from the reference at left.

# Thumbnail Sketches

### Sketching Ideas

After deciding to paint a particular subject, start sketching ideas. Do not get too concerned with good drawing and details at this point. Your real concern is to get a good compositional layout that appeals to you. It is the first step in the creation process that can get you excited about doing the painting.

Sketch quickly, drawing several of the same ideas with variations on the composition. The important thing is to get your idea down on paper and see what you think of it. Why does that idea appeal to you? What is it about that particular creature that you find intriguing? What kind of environment and composition can you arrange to get your idea into a painting?

Some of these sketches will never leave your sketchbook, but you may find it useful to get your painting ideas recorded like this. Old sketchbooks are often inspiration for new paintings.

### Refining Ideas

Once you have settled on an idea, use these thumbnail sketches to experiment with values and composition changes. Then you can enlarge the layout and begin to refine the idea.

### Researching Your Subject

This is a good time to start researching your subject's anatomy, habits and habitat. These are key factors in accurate wildlife paintings, regardless of an artist's painting style or composition.

When you place a bird into an environment in your painting, you need to be sure that the bird is the right size in relationship to the surroundings and that those surroundings are correct for that species. Some birds, like ducks, go through plumage changes during certain times of the year. Consequently, the vegetation and the appearance of the bird each have to be correct for that particular season that you are portraying.

Your research may alter your original sketch and painting plan, inspiring you to take a different direction. With more knowledge comes more interest and excitement, and more confidence in your ability to capture your idea correctly in your painting.

Spark your ideas for a painting with small sketches (the ones shown here were ideas for the artwork on pages 12-13).

# More Thumbnail Sketches

These thumbnail sketches are taken directly from my sketchbook and are reproduced here at actual size. The sketches that are more developed show more work with values and surroundings. These had a stronger sense of design, so I put more effort into them to see how they might develop as a painting. The sketch in the lower left caught my attention more than any others. I decided to use that one and this formed the basis for the painting at lower right.

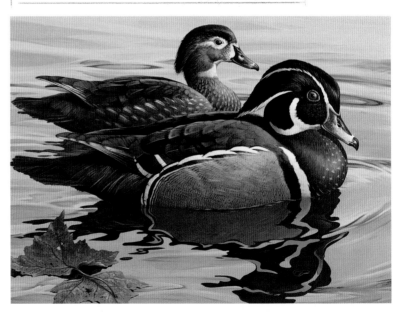

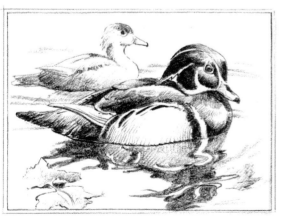

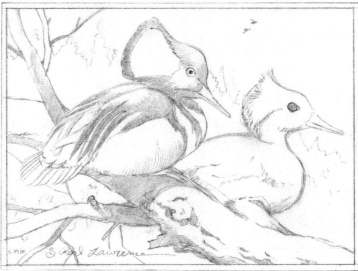

Here are some working thumbnail sketches. The drawing at right was my final choice for the painting below.

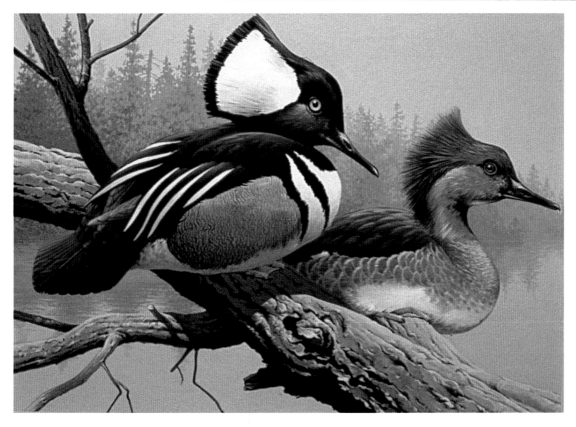

*Hooded Mergansers*
Gouache on illustration board
5" × 7" (13cm × 18cm)
Private collection

# Sketching From Life

Drawing from the real thing just cannot be beat. It is the best form of reference there is. Capture the areas you feel are important, such as details, forms and shadows. These drawings can be important tools for many years.

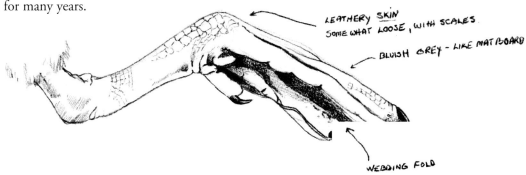

LEATHERY SKIN
SOMEWHAT LOOSE, WITH SCALES

BLUISH GREY - LIKE MAT BOARD

WEBBING FOLD

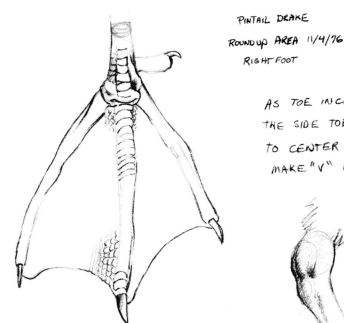

PINTAIL DRAKE

ROUNDUP AREA 11/4/76
RIGHT FOOT

AS TOE IN CENTER COMES BACK + DOWN
THE SIDE TOES RETRACT CLOSER + CLOSER
TO CENTER UNTIL TOUCHING. WEBS
MAKE "V" FOLD

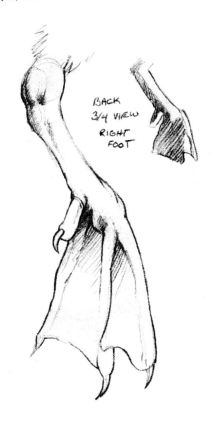

BACK
3/4 VIEW
RIGHT
FOOT

The sketches on this page are shown actual size from my sketchbook. They were done from a specimen in Montana in 1976 and are still helpful to me today.

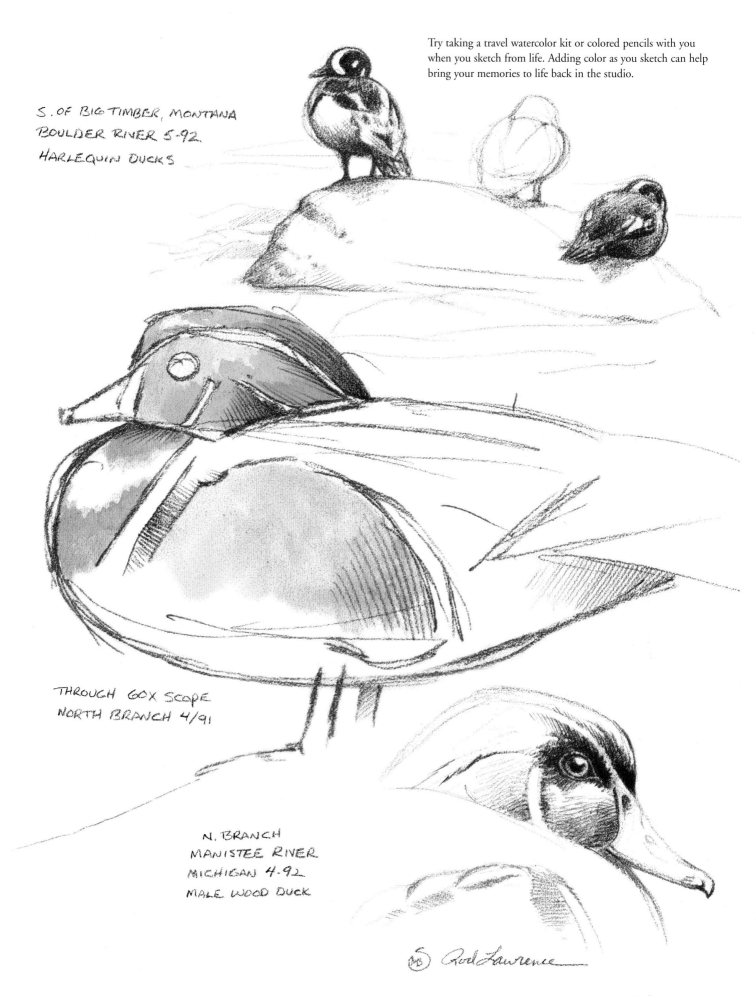

Try taking a travel watercolor kit or colored pencils with you when you sketch from life. Adding color as you sketch can help bring your memories to life back in the studio.

S. OF BIG TIMBER, MONTANA
BOULDER RIVER 5·92
HARLEQUIN DUCKS

THROUGH 60X SCOPE
NORTH BRANCH 4/91

N. BRANCH
MANISTEE RIVER
MICHIGAN 4·92
MALE WOOD DUCK

Rod Lawrence

# Sketching the Environment

If you are trying to portray a particular species, you will want that species existing in its proper setting. You do not want to see a flamingo standing on an iceberg in Alaska! There will be people who look at your painting who know if the situation you are portraying is accurate and believable. And those people will tell you if they think you are wrong. Do some research and make your paintings as accurate as you can. It is a good excuse to get outdoors and experience nature—and it will help your paintings.

Make sketches of interesting locations or arrangements of such things as logs, rocks and plants. Just like the thumbnail sketches of wildlife, these landscape drawings can be the stimuli for later paintings.

These drawings are actual size from one of my sketchbooks. I was commissioned to do a painting of a particular marsh with a pair of flying ducks in the picture. I drove to the marsh and spent a day driving and walking around, trying to get a feel for the marsh. The darker drawings are the ideas that I spent a little more time on. The one in the lower right-hand corner became the background for one of my paintings (facing page).

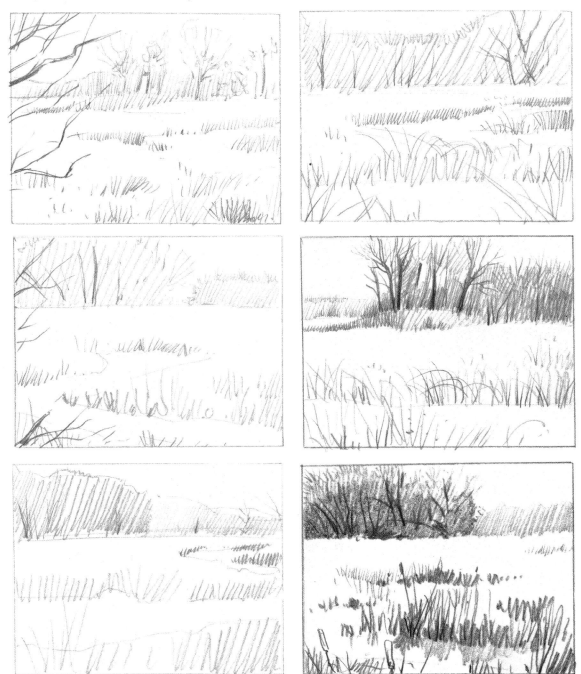

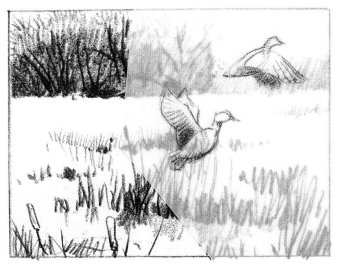

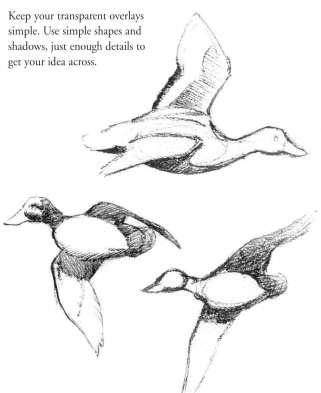

Keep your transparent overlays simple. Use simple shapes and shadows, just enough details to get your idea across.

*Tracing Paper Overlays*

Try adding different elements to your sketches with tracing paper overlays, like the flying ducks shown here. You can try various wing positions and body sizes. After you have determined the size and wing position, slide the tracing paper around to see where your ducks have the best impact and composition. This is a quick and easy way to do a preplanned visual check on your painting, helping you prevent major mistakes and improving your compositions.

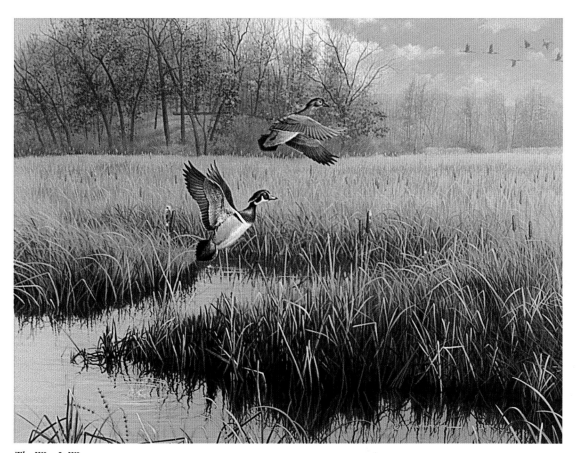

*The Way It Was*
Acrylic on panel
12" × 16" (30cm × 41cm)
Collection of the Michigan Wildlife Habitat Foundation

# Drawing Basic Shapes

Start your drawing of birds with basic, simple shapes. Your strokes should be loose and light, capturing the general shape of the bird.

Picture birds as various sizes of ovals and circles. Then try to draw these shapes in the proper size and relationship to one another.

As the drawing process continues, begin to refine the drawing, indicating smaller shapes and details. Always be aware of the bird's form and three-dimensional shape. The underlying structure of this three-dimensional form dictates feather directions and shadows. Being able to visualize this

form will help you render the bird and understand its anatomy. It is vital that this understanding carry over to the painting process. If not, you could end up painting a feather-patterned, lifeless bird silhouette.

Keep your strokes light on the paper and work with basic large shapes first. You can make corrections as you continue to sketch and determine which lines and shapes are correct.

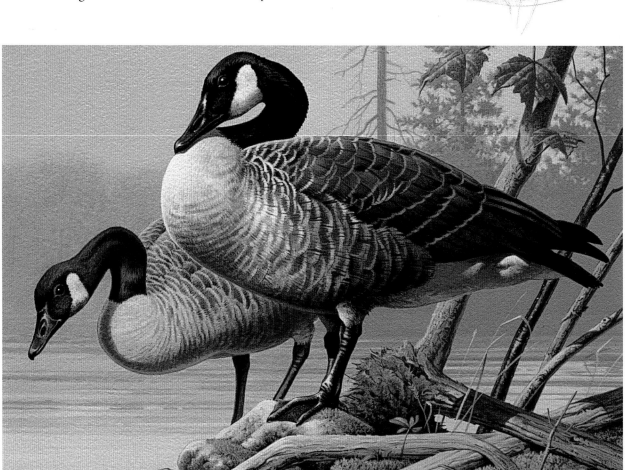

*Morning Glow*
Acrylic on panel
7" × 10" (18cm × 25cm)
Collection of the artist

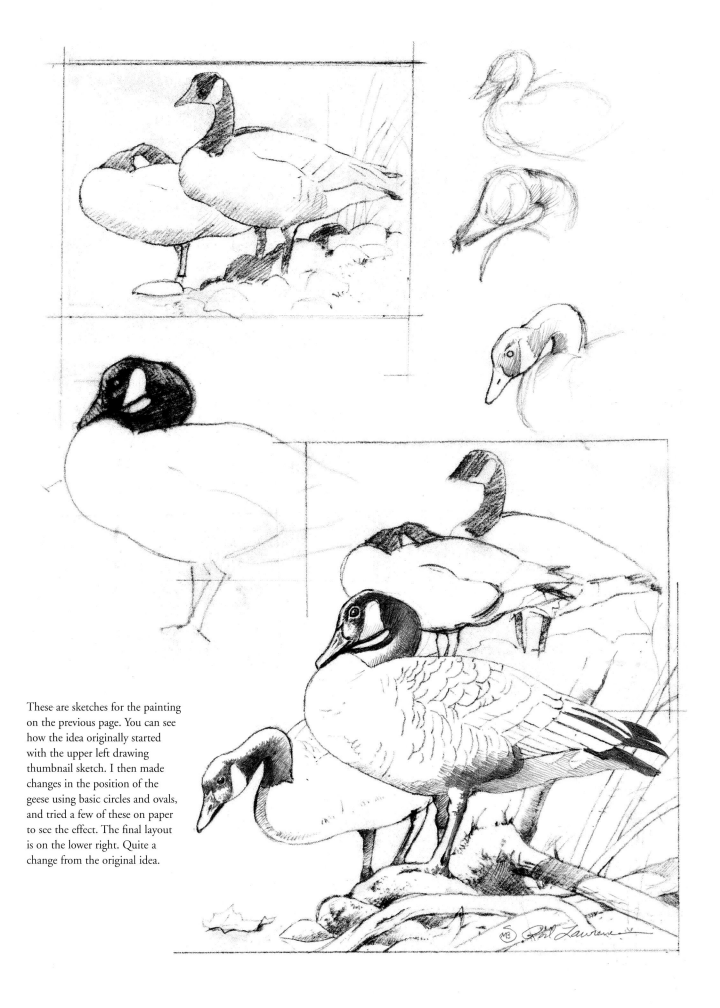

These are sketches for the painting on the previous page. You can see how the idea originally started with the upper left drawing thumbnail sketch. I then made changes in the position of the geese using basic circles and ovals, and tried a few of these on paper to see the effect. The final layout is on the lower right. Quite a change from the original idea.

# Proportions and Scale

## Compare Bird to Habitat

How objects relate to each other in a painting is very important. It provides the eye with a visual reference of one object to another and shows the scale of those objects. For example, if you see a picture of two objects sitting side by side, and you are familiar with one object, then you have a very good idea of how big the other object is. Let's say you see a picture of a green-winged teal sitting in the palm of a man's hand. Unless he plays center for the National Basketball Association, you would have a really good idea of the size of a green-winged teal.

Everything you place into your painting should be in the proper scale to every other item. If not, something will appear not quite right about your painting. It is a common problem and is one reason bird identification books are so helpful. Usually, they list the size of the birds and that will help you plan on the scale of other things in your work.

## Compare Feature to Feature

Each feature or area on any subject has a scale and proportion as it relates to its other parts. Use comparisons to check the proportions on the subjects you are painting.

If you are working on a duck, for example, you might start by making sure the head is the right size and shape. Then ask yourself how many heads make up the body of the duck in length and width. That will ensure that the duck has a head and body that are in proper proportion to one another.

You can carry this comparison out as detailed as you want to get. How long is the bill of the duck compared to the length of the head? How does the length of the eye compare to the length of the bill? This comparison method works great, but remember this crucial factor—you must make sure the item you select for comparison is correct and that you use it for most other comparisons. Making comparisons with things that are wrong to begin with leads to even more errors.

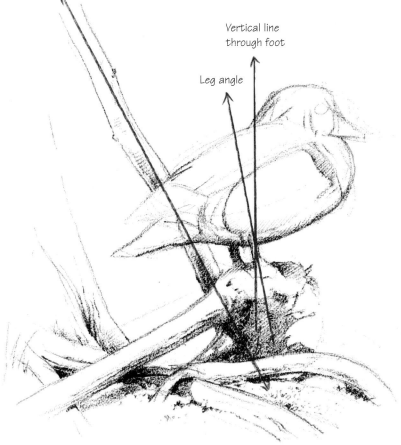

Vertical line
through foot

Leg angle

Here is a sketch from life of a wood duck drake. I used comparison of the head to the body to get the proper portions and made similar comparisons with the drake's major body parts and shapes. By comparing straight lines drawn or visualized from the bird to his habitat, I determined the proper angles of the trees and proper intersection points of the duck. For example, a vertical line from the back of the drake's head would line up right where his right leg would exit the body. A straight line following the proper angle of that leg would bisect the line of his back at approximately one-quarter of the distance between the back of the head and the tree extending behind his tail.

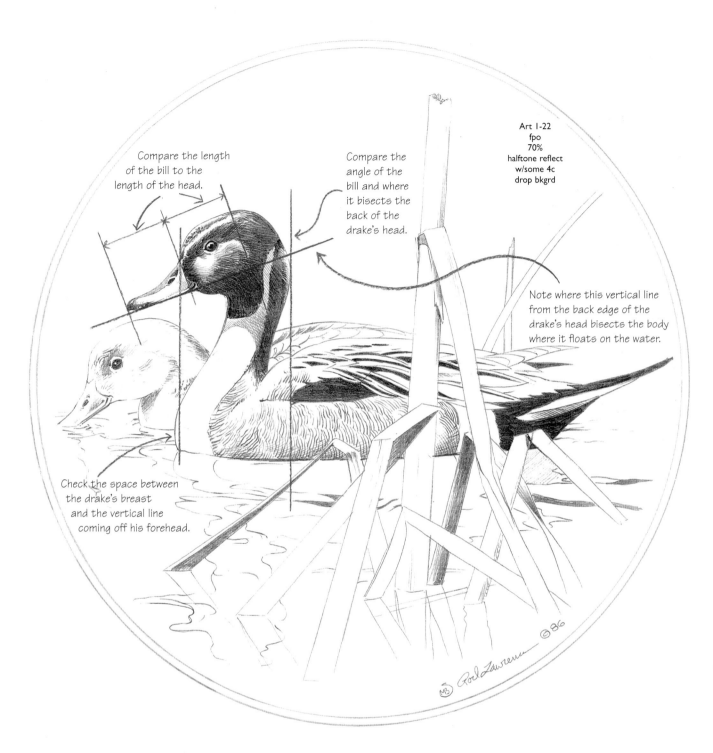

Compare the length of the bill to the length of the head.

Compare the angle of the bill and where it bisects the back of the drake's head.

Art 1-22
fpo
70%
halftone reflect
w/some 4c
drop bkgrd

Note where this vertical line from the back edge of the drake's head bisects the body where it floats on the water.

Check the space between the drake's breast and the vertical line coming off his forehead.

## Compare Intersecting Angles

Another aid in your painting and drawing is to notice the intersections of shapes and lines. If you are working from something like a mount or photograph, look to see where each shape or line meets another shape. Check the angle of the intersection. Then check to see if your drawing and reference material match with this line intersection. I use this method all the time and think it is an extremely valuable process. It works for quick sketching or for more elaborate layout drawing and painting.

This is a final layout drawing for a plate design of a pintail drake and hen. The red lines show some areas that can be checked using the intersection comparison method. After I was satisfied with the ducks' anatomical proportions, I checked the size of the ducks and then gathered some cattails to see how they compared to each other.

# The Importance of Shadows and Light

Where is your light source? What kind of day is it in your painting? Ask yourself these questions as you develop your sketches and paintings. Light has the most dramatic impact on your painting. Let's face it, if there were no light you would not have to be worried about tackling a white canvas—you would have a black one! Light varies the effect it has on your subject based on the conditions and time of the day. I love the late afternoon sun that casts an orange-red glow on everything. The quality of light on a misty morning, with its somber effect, is also intriguing.

A good example of the effect of light is to look at a winter snow scene. Check out the difference in the color of the shadows depending on the day. Even the color of the snow is affected. There is a lot of reflected light in winter time. The winter shadows are grayer on overcast or partly sunny days. On those bright, blue-sky days, the shadows are bluer and more intense.

In your painting, where the light strikes your bird, you must be aware of all the effects of both direct light and reflected light. With a little artistic license, you can use them to help create the effect you want on your bird. The areas of shadow and light are what create the three-dimensional look of your painting. Without them, everything would look flat.

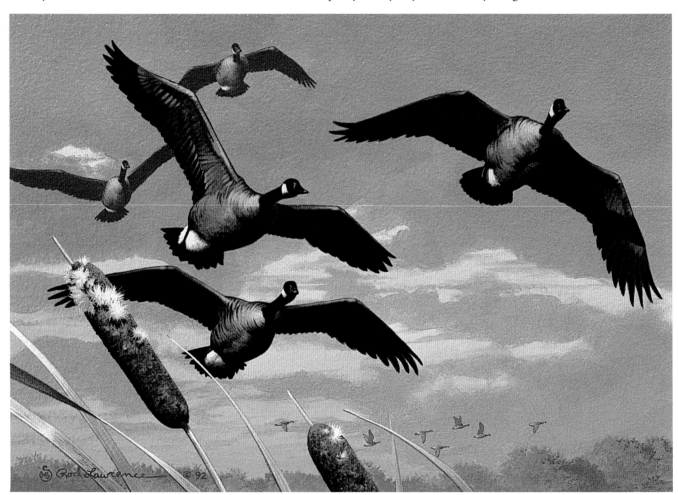

This painting shows the power of both shadow and light. On the geese, the detail is limited entirely to the sunlit surfaces, yet the dramatic shadows are every bit as powerful and important to the impact of the painting. The lighter values of bluish gray shadows on the background geese and trees help give the scene the feeling of low light and distance. The difference in size and color value produces space between the foreground geese.

*Over the Cattails*
Acrylic on panel
7" × 10" (18cm × 25cm)
Collection of the artist

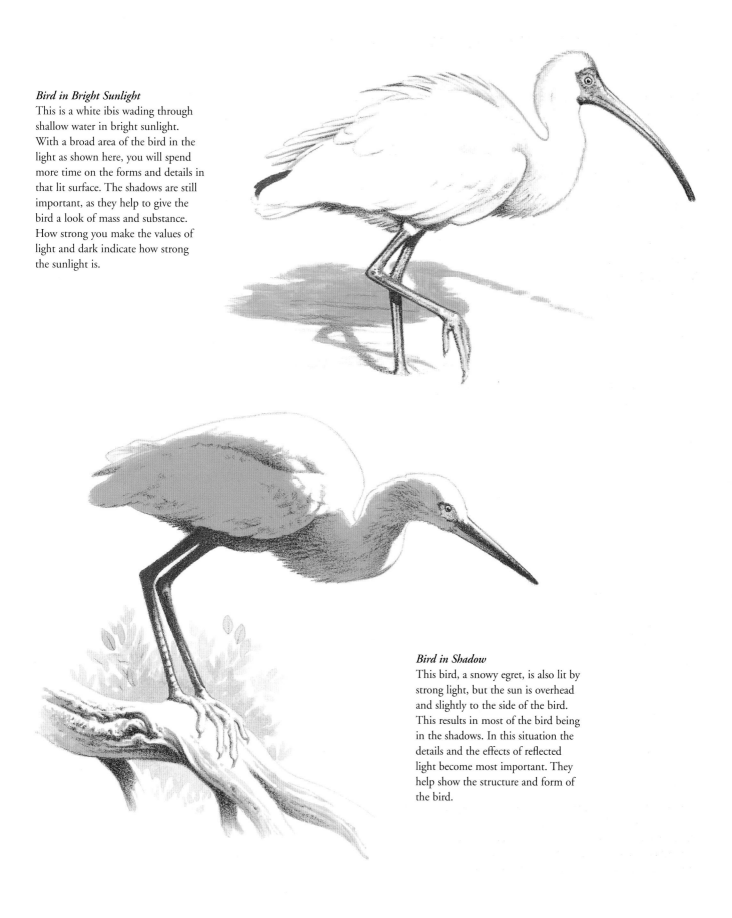

**Bird in Bright Sunlight**
This is a white ibis wading through shallow water in bright sunlight. With a broad area of the bird in the light as shown here, you will spend more time on the forms and details in that lit surface. The shadows are still important, as they help to give the bird a look of mass and substance. How strong you make the values of light and dark indicate how strong the sunlight is.

**Bird in Shadow**
This bird, a snowy egret, is also lit by strong light, but the sun is overhead and slightly to the side of the bird. This results in most of the bird being in the shadows. In this situation the details and the effects of reflected light become most important. They help show the structure and form of the bird.

# The Importance of Color and Value

Color and value go hand in hand with light. For example, on misty or overcast days, the light is not as strong, and consequently, colors are not as intense. Distant colors are even more muted, as are details and values. On sunny days the colors are more intense, the shadows stronger, and as a result there is a greater contrast between light and dark values.

Keep this in mind when you are painting. As a rule, keep the background colors and values of your paintings lighter in value than the foreground. That way, when you place an object in the foreground, these foreground color values of light and dark will show up better and help to give the appearance that this object is in front of the background. This is how things appear in nature.

Take a white object or black object and stand outside with it. Hold it up in front of you and compare the intensity of its values to things around you, both in the foreground and background. You can see that the values of objects are not as dark or light as you might otherwise think. This is one of the pitfalls in relying on photography, as photographs tend to increase the dark values, even in the background, making objects appear darker than they really are.

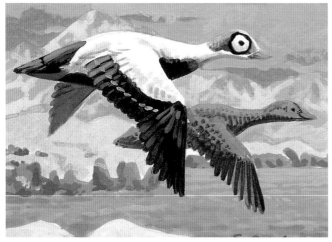

Sometimes doing value studies may result in making some major compositional changes in your painting, such as changing background. In this color sketch the closer bird (the drake) appears to be somewhat blended with the background. The values of the light part of his body look a bit lost against the background, although his head stands out well against the blue sky.

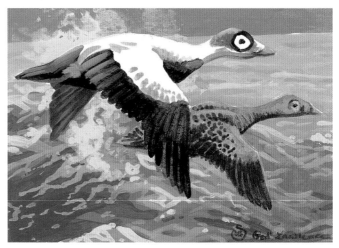

In this color sketch, the darker blue water and deeper blue value in the background give the drake's body more emphasis. The mood seems to have changed here as well, in part due to the action of the waves, and also as a result of the darker values in the water.

The concern here was to create a misty background and a somber, dark feeling as the trees get closer to the foreground. However, any added ducks must still stand out against the background to be effective.

With this background, the dark rump of the drake mallard is darker in value than the background trees, showing that it is closer to the viewer than the background.

## Color Schemes

When you are planning your painting, think about all the effects of light and how they influence color. Don't be afraid to try some other color schemes for a different effect. I sometimes borrow the color scheme of other paintings, which may be totally unrelated in subject matter to what I am painting. But, because I like the color combinations, I will use them to apply to my painting.

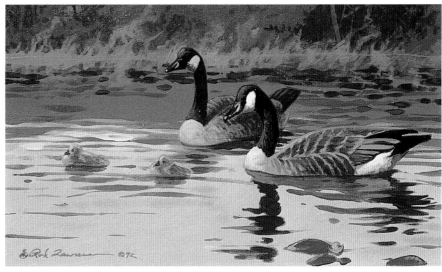

This color sketch has the golden glow of early morning light, with fog rising up from the water.

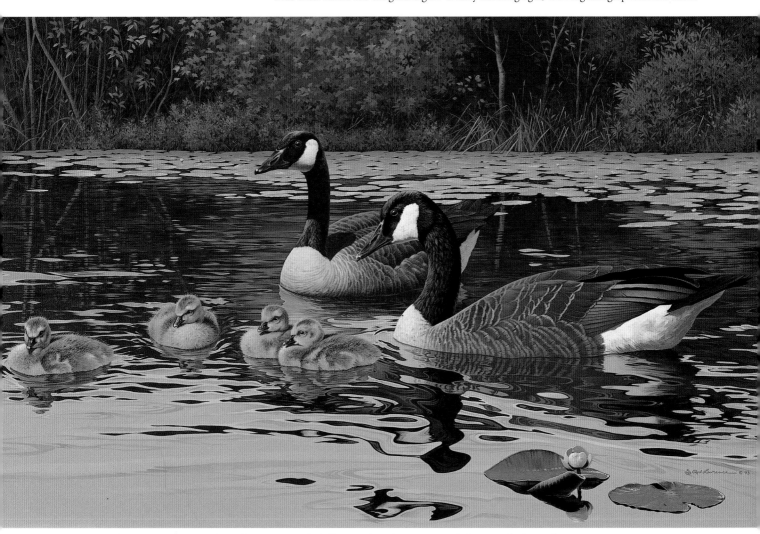

This painting of the same subject as above shows an entirely different color scheme, one with the colors of a typical sunny day. Each painting brings the viewer a different feeling as expressed through choices of color and value.

*Platt's Pond*
Acrylic on panel
29" × 48" (74cm × 122cm)
Private collection

# 2

# ANATOMY

The anatomy of birds can tell you much about the birds themselves. You can determine a lot about a bird's life, such as its habits and food sources, through the size and shape of its body parts. The bill, wings, feet and legs give you clues about each bird and its way of life. Regardless of your painting style, if you want to portray a particular species with some degree of accuracy, you must learn some of its basic anatomical features.

*Canada Geese*
Acrylic on panel
8½" × 11¼" (22cm × 29cm)
Collection of Heatherlee and Gregory Gosnick

# Wings

Base your work, both sketches and paintings, on good reference material. Use mounted birds or photographs for detailed studies, and observe live birds for movement and behavior.

As you observe birds, note the difference in the wing proportions from bird to bird. Wings come in many variations, from the broad wing of a snow goose to the long, slender wing of a ruddy turnstone.

*Ruddy Turnstone Wing*

*Snow Goose Wing*

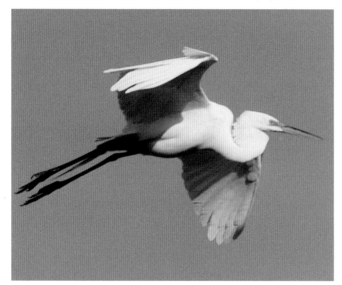

*Great White Heron*

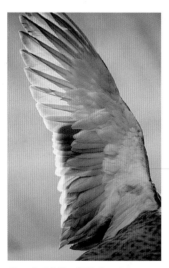

*Female Mallard Underwing*

*Female Mallard Mounted Bird*

*Mallard Ducks*

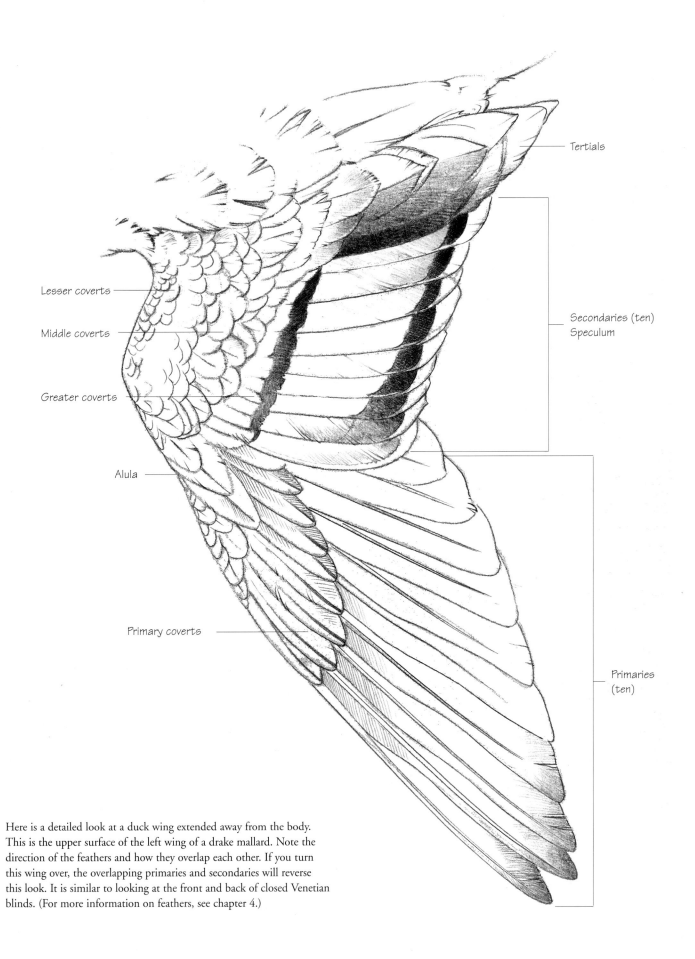

Tertials

Lesser coverts

Middle coverts

Greater coverts

Secondaries (ten)
Speculum

Alula

Primary coverts

Primaries
(ten)

Here is a detailed look at a duck wing extended away from the body.
This is the upper surface of the left wing of a drake mallard. Note the
direction of the feathers and how they overlap each other. If you turn
this wing over, the overlapping primaries and secondaries will reverse
this look. It is similar to looking at the front and back of closed Venetian
blinds. (For more information on feathers, see chapter 4.)

# Feet and Legs

When you are taking reference photos or sketching, remember the feet and legs! You need good material to study how a bird's feet look in the air and on the ground, and how a bird's legs are positioned on its body.

Pay close attention to the joints and how the bird uses its feet in different situations. You can purchase molded bird feet from a taxidermy supply store for reference. These feet are usually cast life-size from molds taken directly from the birds. Study the way the light strikes the feet and see how the shadows are formed.

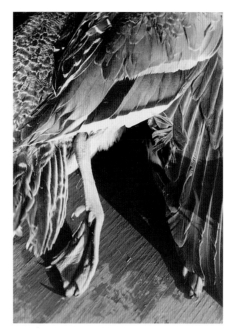

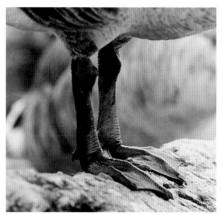

The form of these goose feet is revealed through light and shadow.

Study the toes and webbing of this duck.

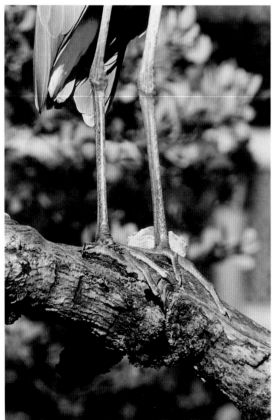

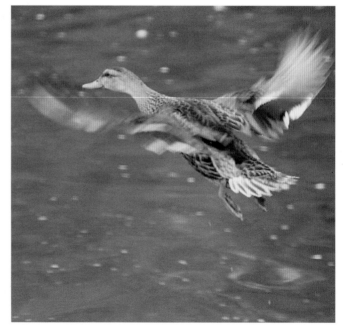

Study the feet position of these flying ducks.

This heron's legs and toes are long and very different from a duck's webbed feet.

## Waders vs. Swimmers

The wading and swimming birds have one really obvious difference—their feet. Each has three toes spread in a triangle shape, but from there they differ.

### Wader's Feet

The wading birds have slender legs and toes. This type of foot is suited to wading along shoreline and shallow water, areas where the birds may encounter rocks, sticks and other bottom debris.

Most of the larger waders build their nests in trees, and these long, flexible toes are helpful for grasping branches.

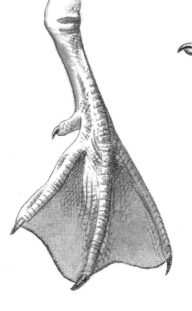

### Swimmer's Feet

The swimming birds have webbing between their toes which serves as a large scoop to propel them through the water.

### Swimmer in Action

Have you ever swum in the water with a pair of diving flippers? Have you ever tried to walk on land with these same flippers?

Try it. You can see why ducks waddle on land. But with their set of flippers below the water and to the rear of their bodies, they really paddle along.

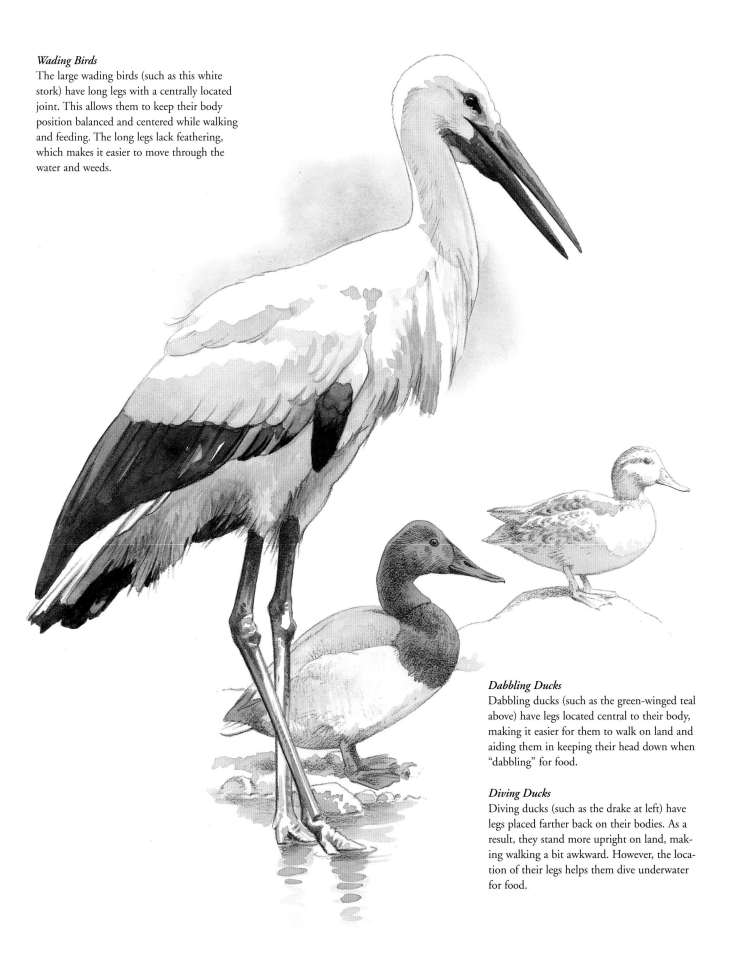

**Wading Birds**

The large wading birds (such as this white stork) have long legs with a centrally located joint. This allows them to keep their body position balanced and centered while walking and feeding. The long legs lack feathering, which makes it easier to move through the water and weeds.

**Dabbling Ducks**

Dabbling ducks (such as the green-winged teal above) have legs located central to their body, making it easier for them to walk on land and aiding them in keeping their head down when "dabbling" for food.

**Diving Ducks**

Diving ducks (such as the drake at left) have legs placed farther back on their bodies. As a result, they stand more upright on land, making walking a bit awkward. However, the location of their legs helps them dive underwater for food.

# Snow Goose Feet
## ACRYLIC

This is a good example of what a webbed foot, such as you would see on waterfowl, looks like when bent back. You can see how the webbing folds when the long toes come together. Notice how it hangs off the side of the body. This is how the foot might appear when the bird is swimming or flying. The strong light helps show the scaling and details, as well as the folds of webbing.

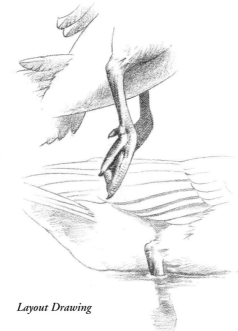

*Layout Drawing*

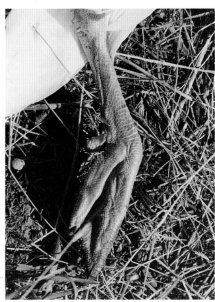

*Reference Photo*

### MATERIALS

**Surface**
Strathmore 500
  Series bristol board

**Paint**
Burnt Umber
Cerulean Blue
Quinacridone Violet
Titanium White
Ultramarine Blue
Yellow Ochre

**Brush**
no. 2 round sable

## STEP 1: *Lay Basic Color*

Start with the two major color values of the foot. The first is the section of the foot in the light.

The photo is a little washed out, so use more of the darker "red" color than you see as your base. Quinacridone Violet is strong, so tone it down with some white, ochre and umber.

Then apply the midvalue shadow color on the leg and foot by adding umber and Cerulean Blue to the red. Be careful not to make this too dark.

## STEP 2: *Add Darkest Darks and Lightest Lights*

Continue with your midvalue shadow color to add subtle changes in shadow and detail. Then add even darker values to the areas of shadow that need a stronger effect for depth and detail.

Apply a lighter value to indicate the sunlight striking the foot. Start by using thin washes, using lighter and lighter values as you model the foot and give it form.

# Willet Feet

WATERCOLOR

The willet has long slender legs like many of the wading birds. They have no webbing between their long and slender toes. The joints are small and do not form as much of a mass on the legs when compared to the waterfowl. This willet is walking and just starting to lift his left foot off the beach. You can see how the toes flex and curve as he begins to take a step

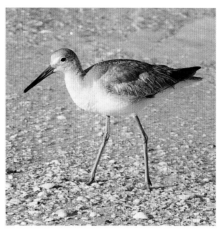

*Reference Photo*

MATERIALS

**Surface**
Arches 300-lb.
   (640gsm) hot-press
   watercolor paper

**Paint**
Alizarin Crimson
Burnt Umber
Cadmium Orange
Cadmium Yellow
   Pale
Cerulean Blue
French Ultramarine
Yellow Ochre

**Brush**
no. 2 round sable

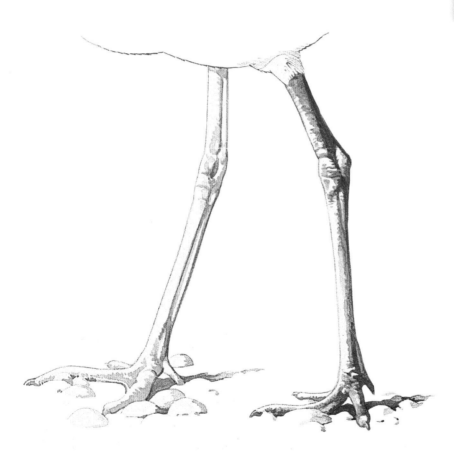

### STEP 2: *Apply Darker Shadow Washes*

Use more Burnt Umber and Cerulean Blue to paint the shadows and suggest some details. Start with thin washes to make the value changes subtle and then build on some of these areas with more applications of paint. This allows you to draw somewhat with your paint and also provides a variety of color and values.

### STEP 1: *Apply Light Washes*

Start with a light value wash of Burnt Umber, Cerulean Blue and Cadmium Yellow Pale. Be careful to plan and protect the light areas of the legs. These are areas that indicate the strong effect of sunlight and highlights.

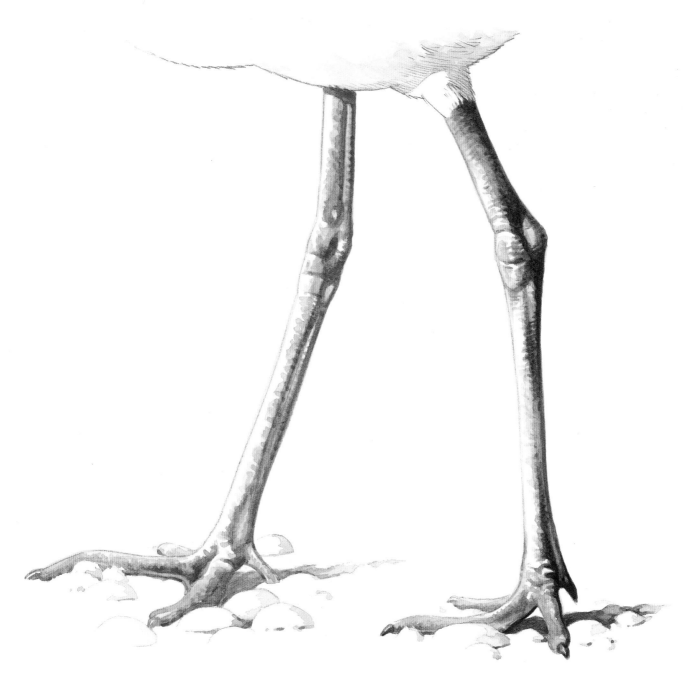

## STEP 3: *Add Color Washes*

Now is the time to wash in areas of more intense color and shadows. Be careful not to stray into the darker areas and pick up that color with your brush, unless you purposely do it to soften that area.

## STEP 4: *Add Finishing Details*

Add the darker value to sharpen the shadows and increase the contrast of colors, using Burnt Umber and French Ultramarine. This will be the dramatic conclusion and make your painting stand out.

# Canada Goose Feet
## ACRYLIC

When a goose stands, you can see the top part of the leg is feathered. This is not as obvious when you see waterfowl flying or swimming. The webbing between the toes is spread flat as the bird stands. There are deeper folds and wrinkles at the base of the leg where it joins the foot. Even though much of the leg is in shadow, the light helps to show some of the foot scales and details. In this demonstration, the goose and leg are facing directly at you.

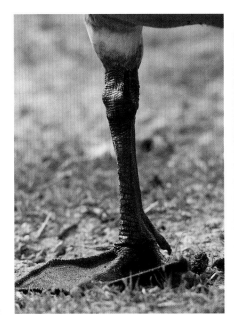

*Reference Photo*

**MATERIALS**

**Surface**
Strathmore 500
  Series bristol board

**Paint**
Burnt Umber
Cerulean Blue
Quinacridone Violet
Titanium White
Ultramarine Blue
Yellow Ochre

**Brush**
no. 2 round sable

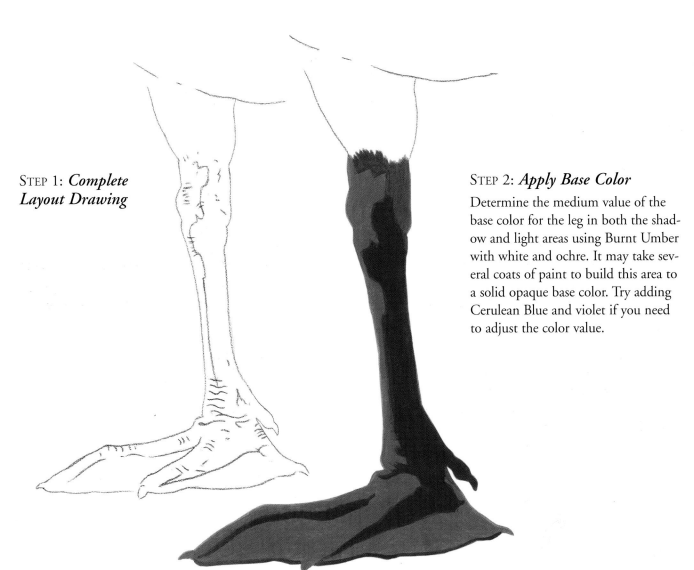

STEP 1: *Complete Layout Drawing*

STEP 2: *Apply Base Color*

Determine the medium value of the base color for the leg in both the shadow and light areas using Burnt Umber with white and ochre. It may take several coats of paint to build this area to a solid opaque base color. Try adding Cerulean Blue and violet if you need to adjust the color value.

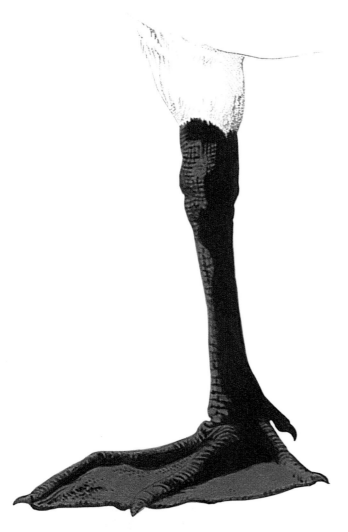

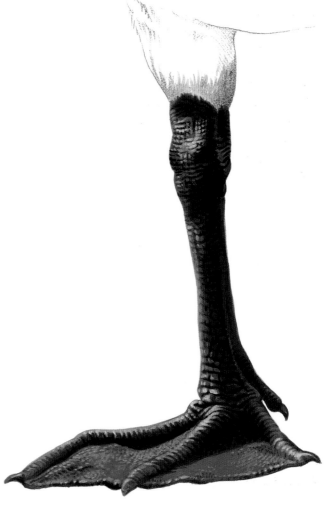

### STEP 3: *Apply Shadow Color*

Transfer your layout drawing to the painting for guidance in the details of the foot and leg.

Then, with a color darker in value than step 2, wash in some of the details and shadows. Use Cerulean Blue and Burnt Umber to darken your values for shadows. The blue helps to balance the warmer, reddish brown color of the umber. If necessary, Ultramarine Blue will help deepen the umber even further. Start with thin washes and then use thicker, more opaque paint, molding the leg and foot to three-dimensional forms.

### STEP 4: *Apply Lighter Values*

This is the reverse of step 3. Use increasingly lighter values to wash and slowly build on the light areas of the forms. Always save the final dark and light values to make your final strokes.

# Beaks

What can be more important in a live creature than the head? We look to the head to see if a creature is awake, alert or looking at us. We perceive its mood and attitude based on the look of its facial features, much like we do with humans. As with any wild creature, however, what we perceive and what is reality can be quite different. Nevertheless, we still look to the head for information and consequently it is a very important part of painting wildlife, including birds.

Beaks are primarily tools for feeding, but they can also be used for other things such as preening, a tool, courtship and self-defense. Many birds do not just eat with their bills, they use them to gather and kill their food.

The shape and size of the bill tell you much about the owner. Flamingos push their bills along the bottom and siphon the water for organic matter stirred up by the forward motion. The long slender bill of the woodcock is for probing the soft ground for worms, and the long sharp bill of the great blue heron can be used for spearing fish.

The correct shape, proportion and color are important to your work for the sake of accuracy to the species. Some bills even change color during certain periods. The male ruddy duck, for example, has a bill that turns bright blue during the breeding season. Afterwards, it fades back to a grayish black color.

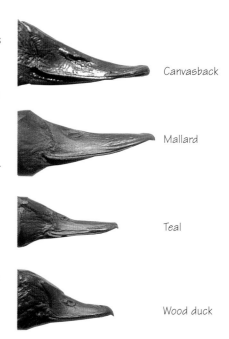

Canvasback

Mallard

Teal

Wood duck

These waterfowl study bills are cast from life.

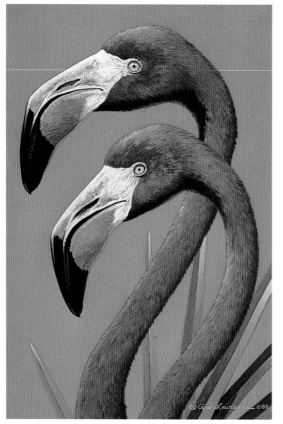

*Flamingo Beaks*

*Green Heron Beak*

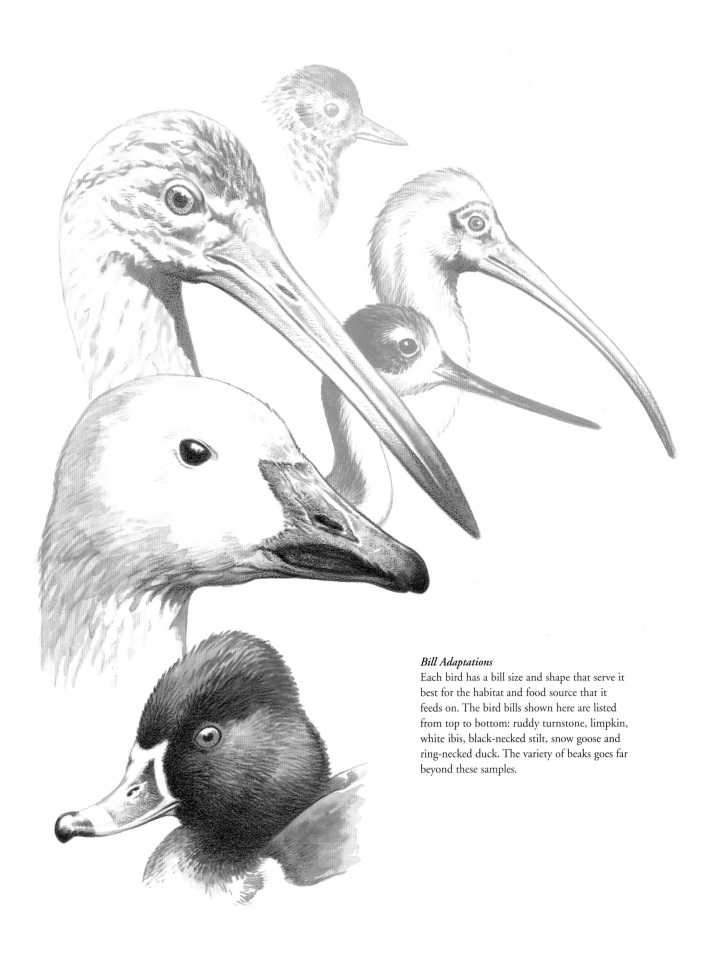

**Bill Adaptations**

Each bird has a bill size and shape that serve it best for the habitat and food source that it feeds on. The bird bills shown here are listed from top to bottom: ruddy turnstone, limpkin, white ibis, black-necked stilt, snow goose and ring-necked duck. The variety of beaks goes far beyond these samples.

Demonstration

# Limpkin Bill
## ACRYLIC

This demonstration of painting a limpkin's bill is good practice for the longer, narrow bills of many wading birds.

*Reference Photo*

### MATERIALS

**Surface**
Strathmore 500
   Series bristol board

**Paint**
Burnt Umber
Cadmium Barium
   Orange
Cadmium Yellow
   Medium
Cerulean Blue
   Chromium
Quinacridone Violet
Titanium White
Ultramarine Blue
Yellow Ochre

**Brushes**
no. 1 and no. 2
   round sables

## STEP 1: *Establish Base Colors*

The bill in the reference photo is a yellow, brownish black. Some of the details and middle values are a reddish or orangish brown. Start with these lighter, middle values as your base color by painting the entire bill a middle-value yellow. Then use a warm brown to paint some of the details. Use washes to build up these areas.

44    WATERFOWL & WADING BIRDS

## STEP 2: *Develop Values*

Add more orange and red value to the brown of step 1, and use light washes to accent the edges of shadow and dark areas, providing a transition area from the dark to light areas.

Add Cerulean Blue Chromium and Burnt Umber to this color to create a darker value and apply this to the dark areas of the bill, building up the color with multiple washes.

Add white and a slightly lavender tint to the yellow to create a light value as highlights on the bill.

Do not go too dark or too light at this step.

## STEP 3: *Refine the Bill*

This last step will accent and define the bill. Mix Burnt Umber and Ultramarine Blue to a neutral, dark color. Thinly apply this color on the nasal opening and bill base.

Then use white tinted with Yellow Ochre and a bit of violet to accent the bill highlights near the nostril, bill base, and the tip and upper edge of the top beak.

Use several coats of thicker, pure white in those key white areas in front of the nostril, and the edge of the upper beak, about halfway above the dark shadow area.

# American Widgeon Bill
## WATERCOLOR

This demonstration of painting an American widgeon bill is good practice for the shorter, wider bills of many waterfowl species.

### MATERIALS

**Surface**
Arches 300-lb.
   (640gsm) rough
   watercolor paper

**Paint**
Alizarin Crimson
Burnt Umber
Cadmium Yellow
   Pale
Cerulean Blue
French Ultramarine
Yellow Ochre

**Brushes**
no. 1 and no. 2
   round sables

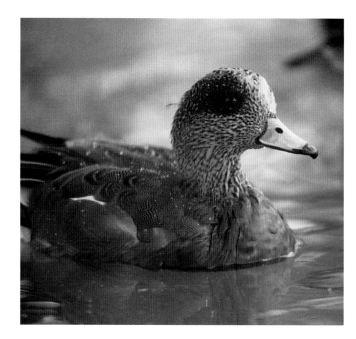

*Reference Photo*
Although the lighting in this photo is not strong, it shows the effect of light coming from the upper right.

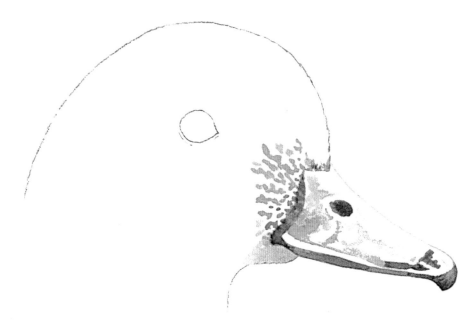

### STEP 1: *Apply Light Washes*

Use light washes of Burnt Umber and French Ultramarine to suggest some of the bill's form and shape.

Create a medium dark value to paint in the bill base and lower edge from the tip of the bill.

Allow the white of the paper to remain in areas where the light is striking the bill.

## STEP 2: *Develop Values*

Use light washes of Cerulean Blue to build up the color in the middle area of the bill. Work quickly to not dissolve any of the underlying color.

Before this wash is totally dry, work on any areas that need to be softened or darkened. Add more of a grayer wash to the tip of the bill.

Do not go too dark with your values at this stage.

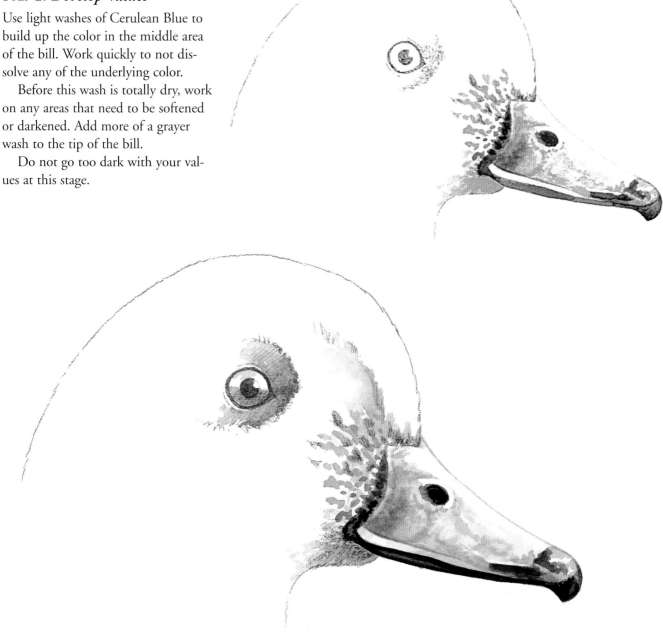

## STEP 3: *Refine the Bill*

Use additional washes of color to add darker details in some areas, and use water and a tissue to blot and soften other areas (such as where the bill meets the head).

Use your darkest value to accent the dark area of the lower bill, the tip of the upper bill and the nasal opening.

# Eyes

When compared to their head size, birds have very large eyes. And like most wildlife subjects, the eyes are an important part of painting the subject.

From a distance, we see an eye in its simple form, as a round, dark circle with a highlight in it. No more than this is needed when painting birds in the distance.

As a bird moves closer to the foreground, however, details in the eye become more evident. The difference between the iris and the pupil is noticeable. The color of the iris is visible.

## Shape of the Eye

The eye is not just a round circle; it is a three-dimensional object. In most birds it appears as a flattened circle, but in some birds, like raptors, the eye is a tubular shape.

The eye is set into the socket and surrounded by skin and feathers, helping give the eye its distinctive shape.

When painting a bird, take the species' eye size and color into account for an accurate portrayal.

## Reflections in the Eye

Each bird has a thin, transparent membrane (nictitating membrane) in its eye that helps clean and moisten the front of the eye.

This moist, three-dimensional eye reflects its surroundings. The bright highlight you see is, under natural lighting, the brightest thing in front of the eye. If you look closely, you can see the sky, background and light area reflected as well. Have someone stand in front of you and look closely into his eyes. You will see what I'm talking about. The eye becomes a kind of window on the world!

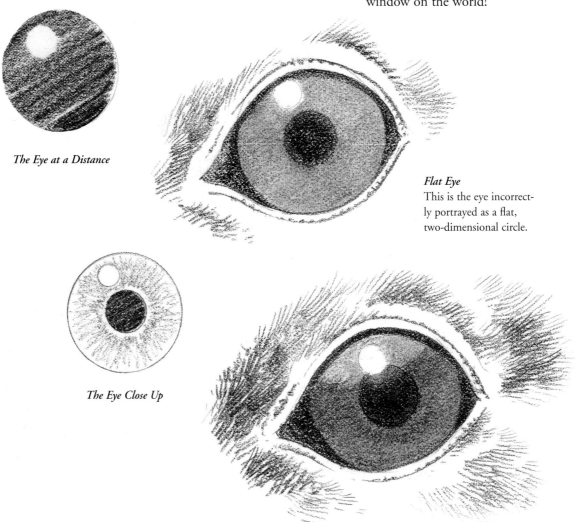

*The Eye at a Distance*

*The Eye Close Up*

**Flat Eye**
This is the eye incorrectly portrayed as a flat, two-dimensional circle.

**Three-Dimensional Eye**
This is an accurate portrayal of an eye, shown as a three-dimensional object, modeled by its surrounding skin and feathers.

# Canvasback Drake Eye
## WATERCOLOR

This demonstration will give you practice in creating the three-dimensional form of birds' eyes.

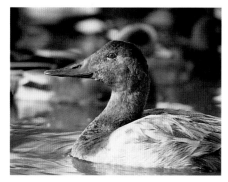

*Reference Photo*

### MATERIALS

**Surface**
Strathmore 500
 Series bristol board

**Paint**
Alizarin Crimson
Burnt Umber
Cadmium Scarlet
Cerulean Blue
French Ultramarine
Winsor Red
Yellow Ochre

**Brush**
no. 2 round sable

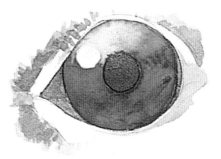

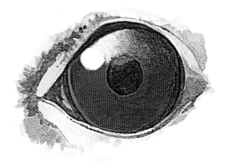

### STEP 1: *Preliminary Washes*

Use an Alizarin Crimson/Cadmium Scarlet mix to "sketch" in the iris of this eye, starting under the highlight and working around the bottom of the eye.

Wet the top, reflective area of the eye with water and slightly bleed the iris color into this area. Add French Ultramarine to your red as a light lavender and allow the red and lavender to bleed into each other on the right side of this reflective area.

Dry.

Mix French Ultramarine and Burnt Umber to apply the pupil and side areas of the eye.

### STEP 2: *Build Colors*

Use thicker paint to build up the intensity on the bottom half of the iris.

Paint Cadmium Scarlet on the left half of the iris and a Winsor Red/Alizarin Crimson mix on the right half to warm the iris color.

Add more lavender to the reflective area at the top of the iris, blending it darker into the red.

Add a touch of Burnt Umber to the lavender and paint the shadow of the eyelid on the iris.

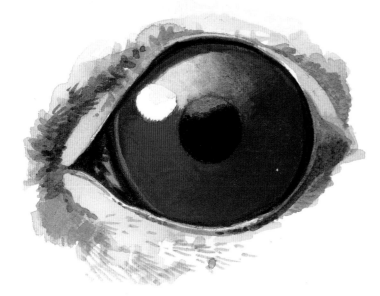

### STEP 3: *Add Final Details*

Darken the red on the right side of the iris to enhance the three-dimensional quality of the eye.

Use a Burnt Umber/French Ultramarine mix to darken the area around the iris, the outside edge of the shadow and the pupil. Leave some of the reddish brown on the shadow over the eye as it adds to that three-dimensional look.

Leave a portion on the top half of the pupil the bluish gray color so it becomes a part of the reflection.

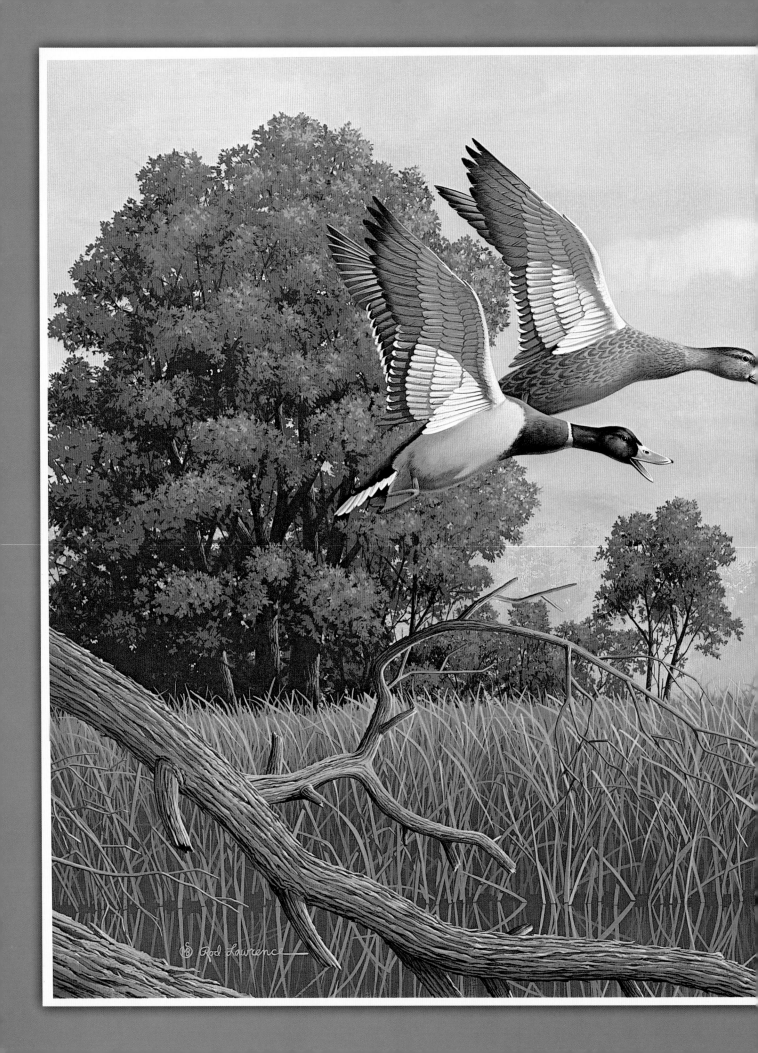

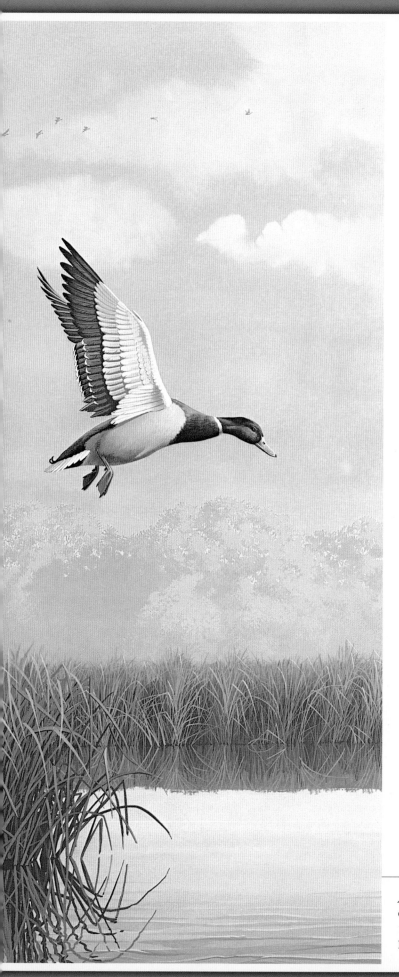

# 3

# ACTION

When it comes to action, the waterfowl and wading birds have some very different habits. The actions of these birds can be based on several things, such as feeding, breeding and transportation. For accuracy in your artwork, it is important to have the correct action and situation for the particular bird you are painting.

Wading birds spend much of their time walking on land, although it might be in shallow water or mud flats. Their legs and bills are suited to this type of lifestyle.

Waterfowl on the other hand, spend much of their time swimming in water. Their legs and bills are well suited for this type of habitat and life. They will feed in fields and some even can be seen in trees during nesting, but overall, the wading birds are far more adapted to walking and the waterfowl to swimming.

*Autumn Wings*
Gouache on illustration board
16" × 20" (41cm × 51cm)
Private collection

# Feeding

The feeding activities among birds are as varied as their anatomy and point out the concept of form following function.

The actual food source of birds is also important to research. Some species, such as the herons, feed on fish. Birds like the rail family may feed on crustaceans and worms. Some waterfowl species are vegetarian, while others feed on both vegetation and aquatic animals.

White ibis frequent the shoreline and use their beaks to probe the sand for food. Their beaks are very sensitive and allow them to tell how big an object is.

The smaller short-legged birds like this black-bellied plover (winter plumage) are restricted to the shoreline. Their small legs allow them to wander the edges of water quickly in search of food.

The long legs of the herons and cranes are used for wading the shallow water and marshes. The long, widespread toes help keep these birds from sinking into the soft bottom. Their long, supple necks provide vision over the weeds and allow the birds to reach down for feeding through both weeds and water.

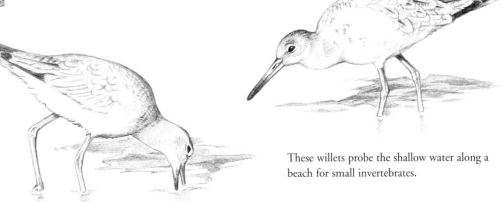

These willets probe the shallow water along a beach for small invertebrates.

## Dabblers vs. Divers

The family of ducks, geese and swans are divided into several subfamilies and tribes. However, many ducks are commonly divided into two groups called dabbling and diving ducks.

Dabbling ducks are so called because they generally tilt forward in the water to feed. Their tails will stick upright in the air and their heads extend down to the food source. Diving ducks also do just what their name implies. They generally dive completely underwater and swim down to their food source, sometimes at great depths.

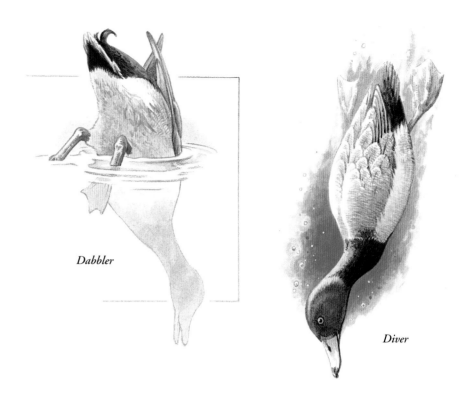

*Dabbler*

*Diver*

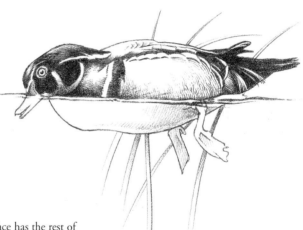

### Body Shape

Sometimes we forget that, like an iceberg, the form we see floating on the surface has the rest of its shape below the water. By looking at waterfowl in transparent tanks that show you both above- and below-water views, you can get an understanding of the bird's movement in water. Note how much of this wood duck drake's stomach and chest are below the surface. Now you can see why waterfowl produce a frontal wave and a noticeable wake while swimming in the water.

When the duck stretches out on the water, you can see that the form underneath also changes shape. This is from the bird's movement and the support of the water.

# Flying

Of all the abilities that birds have, the unique ability to fly separates them from all other animals, except the bat. Birds' wings and feathers are truly a design and engineering marvel.

With high-speed film for stopping action, video cameras and VCRs, you can watch and analyze the flight of birds. These are great tools for understanding the movements of flight and seeing just how the feathers and wings change shape wing beat by wing beat. You can advance a video one frame at a time to change the attitude of a flying bird and help you compose your picture.

Keep in mind that birds use not only their wings but sometimes their tail, feet and the wind direction itself to aid in their flying. Waterfowl typically land against the wind, to help them slow down for the landing.

When you plan your paintings of birds in flight, it is helpful to plan the major elements of the wings, such as the primaries, secondaries and coverts. Many bird species have a specific number of primary, secondary and tail feathers. For example, ducks and geese have only ten primary feathers on each wing. There may be fewer than ten if they have lost some from molting or damage.

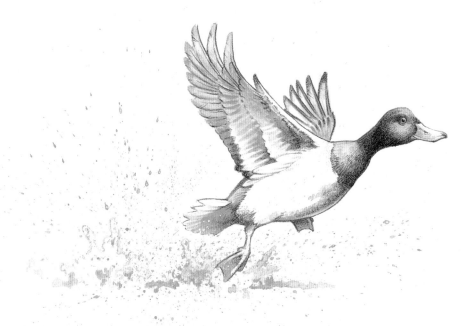

**_Diving Duck Takeoff_**
A diving duck needs some speed and rapid wing motion to get airborne. It will vigorously flap its wings and run across the water before it can get airborne.

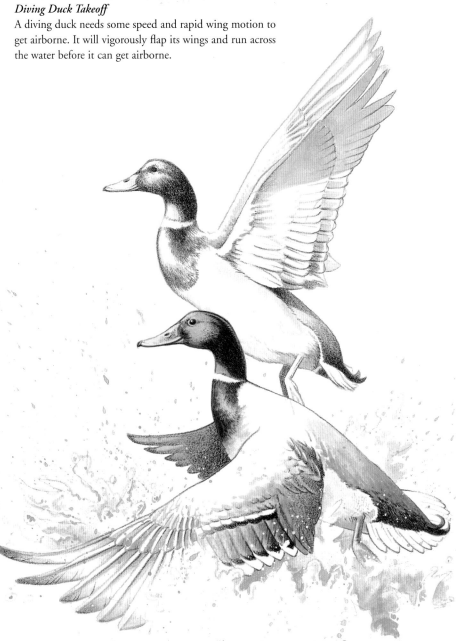

**_Dabbling Duck Takeoff_**
When a dabbling duck takes off in flight from the water, it will spring into the air by slapping its wings on the water surface. It literally flies off the water.

I traced these images from different movie frames, stopping the action to get a specific wing beat. While the images are often not very detailed, they do give you great wing and body positions to start with.

With this beginning, you can use other references for filling in the necessary details. These images can be reversed, enlarged, reduced, overlapped, tilted or altered in other ways. You can even change the sex or species of the bird, with proper reference material.

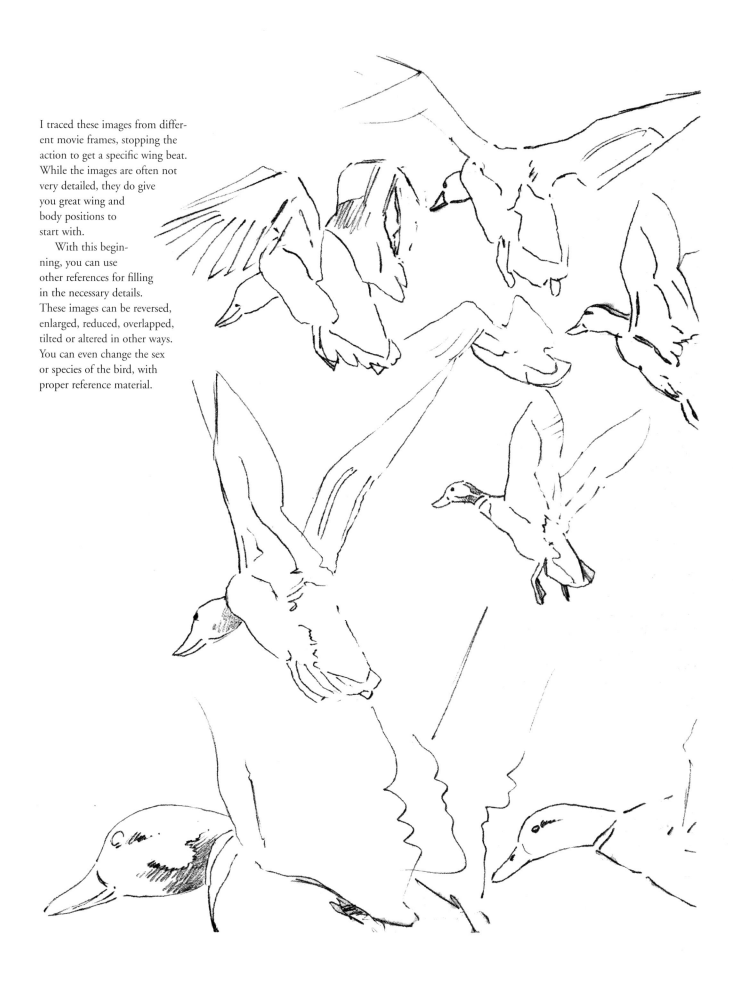

# More on Flying

Some wading birds are strong flyers. Herons and egrets have large, broad wings that only have to flap at a slow rate to keep them flying. When they take to the air, their long necks are stuck out and their long legs trail behind them. Once they are in the air, their heads are pulled back to the body, which helps center their weight and gravity, and their legs remain stretched out behind them.

The smaller wading birds have smaller wings and a much more rapid wing beat. This makes them faster and more agile flyers.

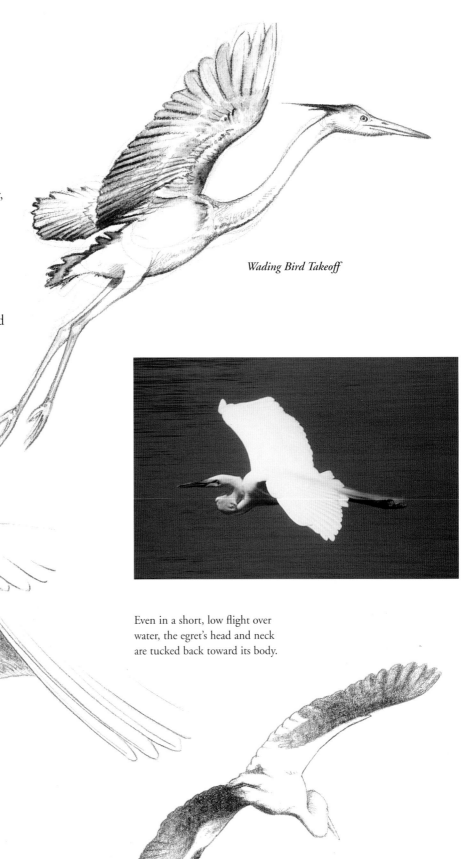

*Wading Bird Takeoff*

Even in a short, low flight over water, the egret's head and neck are tucked back toward its body.

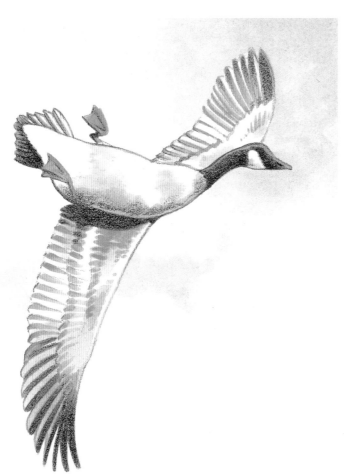

### Having Fun With Flight

It has been called a lot of things, but many geese and some ducks perform some incredible aerial maneuvers. Tumbling, whiffling, or whatever you call it, the birds must call it fun. They will roll and flip upside down, sideslipping through the air. I have seen large flocks of snow geese in Saskatchewan, Canada, tumble down and then pull up to land in the water. From a distance they look like huge snowflakes falling.

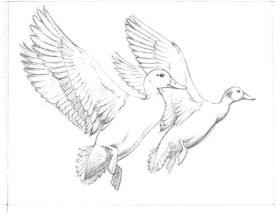

When planning a painting of birds in flight, be careful to accurately reproduce the wing feathers, including the axillars, primaries, secondaries and wing lining.

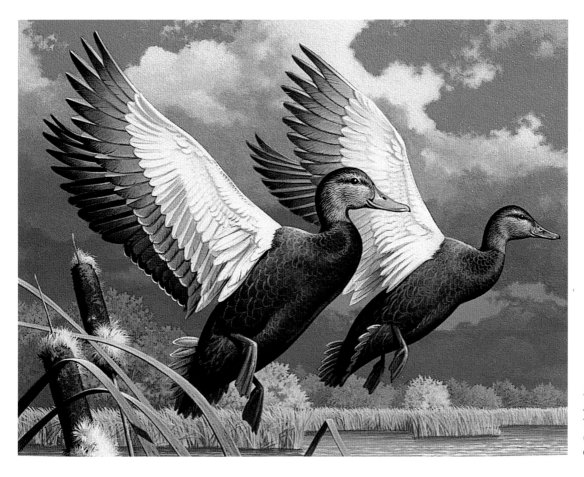

***Black Ducks***
Acrylic
7" × 10"
(18cm × 25cm)
Collection of the artist

# Common Goldeneye in Flight
OIL

This is a small and somewhat simple demonstration of a flying waterfowl, so a lot of detail is not necessary. However, this demo will help you practice painting the shapes of wings in flight, as well as the bird's overall body shape (head, neck, tail and feet) in flight.

### MATERIALS

**Surface**
Solid Ground
  polymer panel

**Paint**
Burnt Umber
Cadmium Red
  Medium
Cadmium Yellow
  Light
Cerulean Blue
English Red Light
French Ultramarine
  Blue
Naples Yellow
Titanium White

**Brushes**
no. 1, no. 2 and no.
  3 round sables

**Other**
Painting medium:
  1 part stand oil/
  1 part damar
  varnish/5 parts
  pure gum spirit
  turpentine

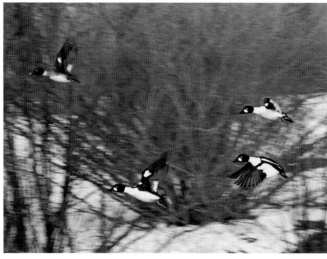

*Reference Photo*
There are three drake common goldeneyes near the center and one female at the top left. Use the drake on the lower right as reference for this demonstration.

  While this photo gives the idea and basic pose, other reference must be used to fill in the missing elements: wing structure and feather pattern.

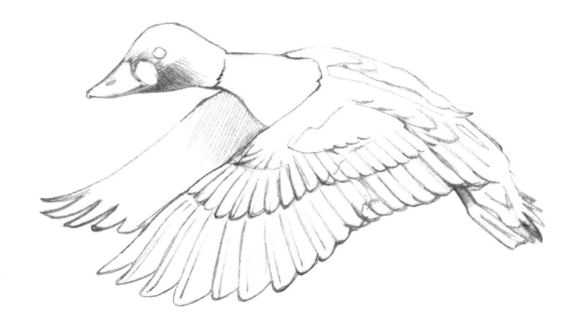

## STEP 1: *Layout Drawing*

It is good to have some of the individual wing feathers planned to make sure they're placed correctly. The wing on the back side, which is the drake's right wing, can be left in shadow as shown in the photograph. While there might be some subtle blending on that wing, it is not enough to need a detailed drawing of the feathers. The tail feathers are indistinct on all the ducks in the reference. Leave your painting the same way and just indicate a few tail feathers as they spread out on this power stroke of flight.

## STEP 2: *Complete Underpainting*

Mix a thin solution of Burnt Umber and painting medium. Paint a thin layer of this mixture all over the duck, even where he is going to be white, such as the body and wings. This will dry quickly, but work right over it immediately to paint in the values. This is a form of "sketching" with the paint.

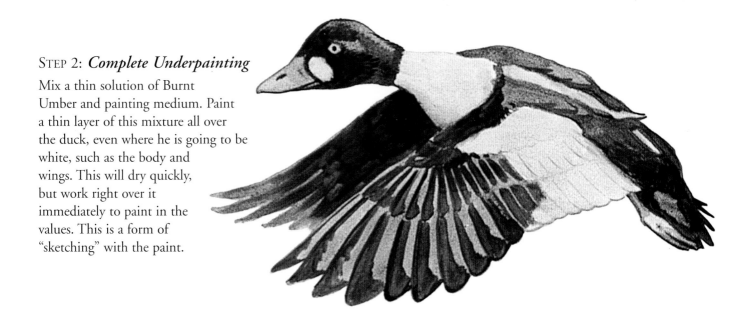

## STEP 3: *Apply a Color Base*

Use one of the smaller brushes, whichever you feel comfortable with, to apply color to the duck. Do not use your darkest or lightest values yet. Leave most of the "white" of the duck's back and wing as the Burnt Umber undercoat, except for the suggestion of bluish shadows under the chest and feathers.

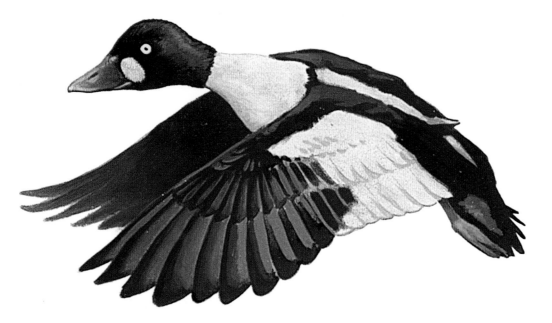

On the wing feathers, paint three different values and then blend them together with your brush. The last four or five on the end of the wing are blended here, but the others have not been. The darkest value at this point is a mixture of Burnt Umber, Cerulean Blue and French Ultramarine Blue.

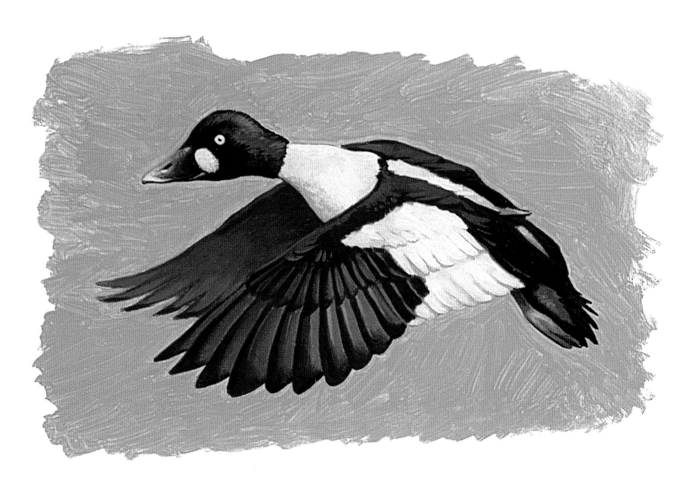

## Step 4: *Continue Adding Color*

Add lighter paint to the body and wing, but keep the value down somewhat. Add some Cerulean Blue and a touch of Burnt Umber to keep the white value slightly blue. It is hard to see the real effect of the white on the duck with that bright white background behind him. Rough in a blue-green sky, to help see the effect of the light and dark pattern of the golden-eye. If you reach a point when everything is wet, and working on the duck starts to become messy, it is time to set the painting aside and let it dry somewhat.

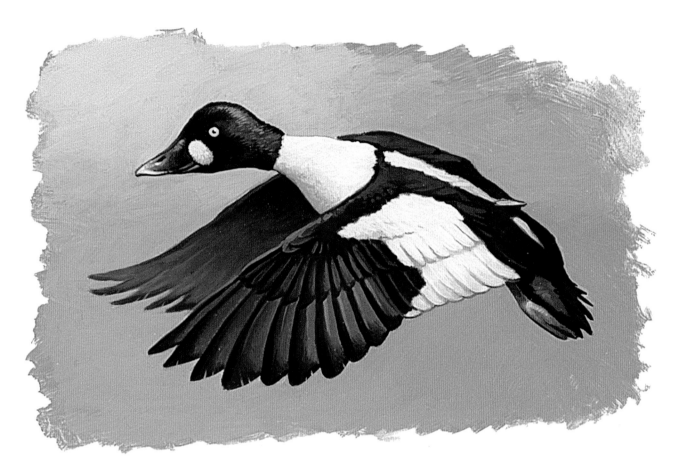

## STEP 5: *Refine Your Painting*

When the painting is dry enough to work on, so you are not dragging off the first layers of paint, start refining the forms, shapes and values with your no. 1 brush. The primary feathers need some attention to define their shape. The head and bill need some more details as well.

When you are satisfied with the duck overall, add the darkest values: a combination of Burnt Umber and French Ultramarine Blue. Use this mix to accent the head, bill and some of the feather tips on the wing and tail

area. The back wing should stay subdued in value so that the foreground wing appears closer to you, giving the illusion of space between the two wings.

Finally, mix a touch of Cadmium Yellow Light and Titanium White to make a "warm" white. Use this mixture to highlight the cheek patch, the top of the body and the upper surface of the wing. Blend this to almost nothing as you work down the wing to the secondary feathers.

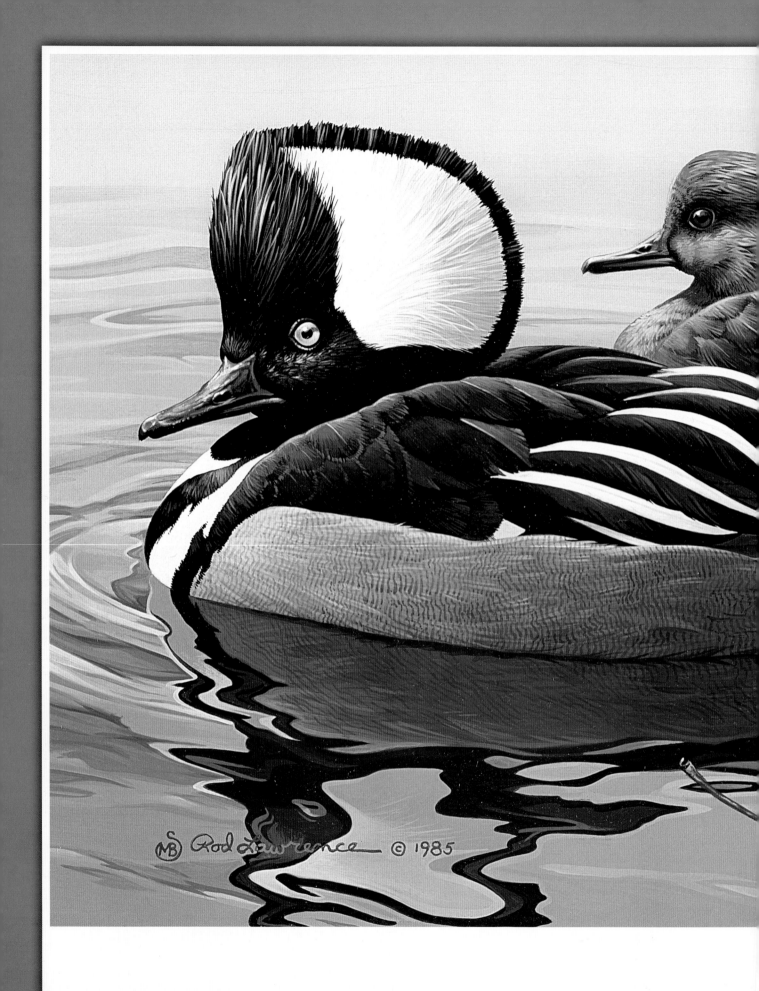

MB Rod Lawrence © 1985

# 4

# PLUMAGE

The feather is synonymous with birds. Feathers serve as insulation against both heat and cold. For some birds, camouflage coloration provides concealment from predators, and for others, bright-colored feathers attract mates for breeding. For many birds, feathers provide their main mode of transportation—flying.

Feathers can be broken down into four main categories: the soft down feathers that are close to the body and provide insulation, the contour feathers that cover the outside of the bird and thus give it shape, the flight feathers that make up the wings, and the filoplumes (hairlike feathers interspersed between the down and contour feathers). For your painting purposes, the contour and flight feathers are the most important as they are the most readily seen.

*Hooded Merganser Pair*
Acrylic on panel
7" × 10" (18cm × 25cm)
Private collection

# Feather Groupings

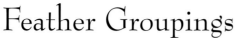

Each feather grouping has a certain name. Knowing these names is helpful when trying to understand what you are seeing when studying both live birds and photographic reference.

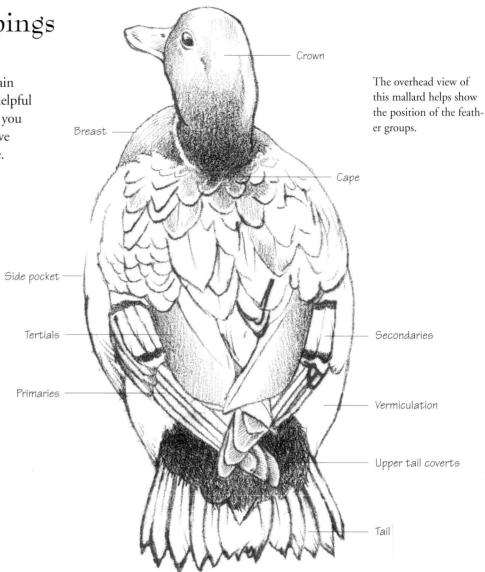

The overhead view of this mallard helps show the position of the feather groups.

Crown

Breast

Cape

Side pocket

Tertials

Secondaries

Primaries

Vermiculation

Upper tail coverts

Tail

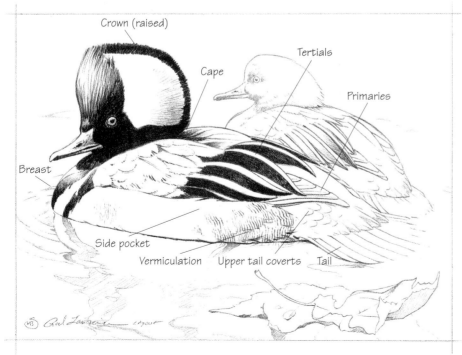

Crown (raised)

Cape

Tertials

Primaries

Breast

Side pocket

Vermiculation

Upper tail coverts

Tail

These hooded mergansers are in a typical pose, a low elevation to the viewer's eye. The secondary feathers are hidden in this pose.

# Feather Patterns

In some birds, the wing feather patterns are very interesting. These patterns and colors can be exclusive to that particular species and help in a visual identification of the bird. Patterns also vary with the age of the bird and can be used to help determine both sex and age.

The willet has a fairly indistinct look when at rest, but when it takes flight, the undersides of the wings have a bold pattern of black-and-white feathers. Many ducks have a gradient color transition due to the iridescence in their secondary wing feathers. These feathers, in marsh ducks, have a beautiful iridescent quality. This colorful speculum varies in color from species to species.

## Preening

Most birds have an oil gland at the base of their tail. By contacting this with their bill, they smear this oily substance over their feathers to shape, coat and protect them. This preening process is a good action to watch and photograph as it exposes many of the bird's feathers.

## Molting

With all their functions and the abuse that they take, feathers wear down, and these damaged feathers must be replaced. Most birds molt annually and replace their feathers with new ones. Some species molt twice during the year. Ducks, geese, swans and many other birds also lose all their flight feathers and for that brief period are totally flightless.

Many male ducks will develop what is called "eclipse plumage" during this molt. These male ducks will have feather patterns and coloration that closely resemble their female counterparts. This gives them some camouflage protection during the brief period when their flight feathers are lost.

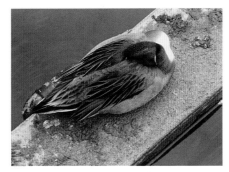 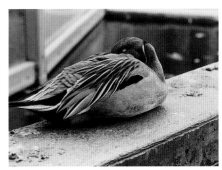

Shoot reference photos from all angles to get a good view of the various feather patterns of your subject.

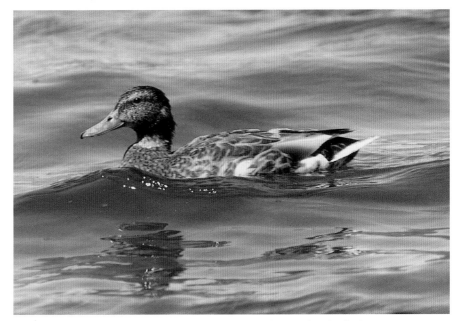

Mallard drake in partial eclipse plumage. This once colorful drake has the feather patterns of a female.

## Do Your Research

The seasonal time period for molting waterfowl varies between the species. It is important to research this for your paintings. Suppose, for example, you do a painting of a species in breeding plumage beside flowering vegetation. For accuracy, you need to know if that plant flowers during the same time that the bird is in his breeding coloration.

# Extended Wing on Male Mallard
ACRYLIC

This demonstration will help familiarize you with the colorful speculum of the mallard wing. When the light changes direction, you can see the beautiful iridescent colors in these feathers.

Notice how the feather shafts are close to the leading edge of the wing on the first few primaries. As the feathers get closer to the body, the shaft is more centered on the feather, and feather tips are more blunt and rounded.

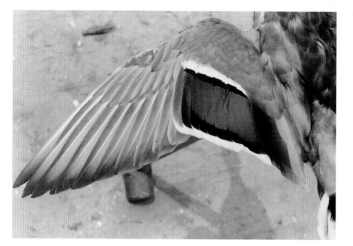

*Wing Reference*

## MATERIALS

**Surface**
Strathmore 500
  Series bristol board

**Paint**
Burnt Umber
Cadmium Barium
  Red Medium
Cerulean Blue
  Chromium
Quinacridone Violet
Titanium White
Ultramarine Blue
Yellow Ochre

**Brush**
no. 1 round sable

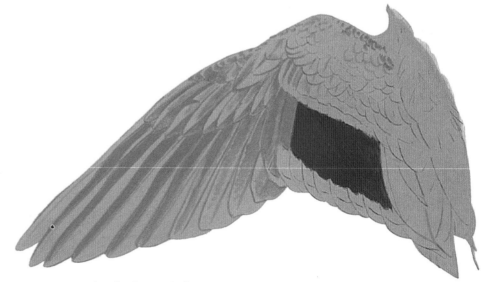

## STEP 1: *Apply Base Color*

Think of the wing as being simplified into some basic color areas. If you squint your eyes to block out details, what one color do you see in each particular color area? This color is your base color.

It will take several thin coats to build up a solid, opaque base color. Once you have the base color done, use tracing paper to transfer your layout drawing back over the basecoat.

Make sure the paint is dry, so you do not transfer too much graphite to the paint surface. Then using a slightly darker value, begin to paint some of the darker areas as you see above on the primaries. Also paint a medium basecoat on the speculum with Quinacridone Violet and Ultramarine Blue, adjusting this mix with Cerulean Blue Chromium, Burnt Umber and perhaps a touch of white as needed.

## STEP 2: *Add Detail*

Use slight, increasingly darker values to begin some suggestions of detail and shadow. Plan this step and build the painting slowly. Keep your paint thin and flowing for easy painting. You can also use thin washes of the same paint to vary the value and effect.

To blend the dark area on the feather tips, use thin washes and dry-brushing.

After you have some details and shadows established, use color washes to make subtle changes and to intensify areas that need more color. Use increasingly lighter values to soften areas and indicate light striking the feathers.

The lightest values are the white areas of the wing and those areas in the brightest light. The whites will take several layers to build up a clean, solid white color. You might add just a tiny dab of yellow to your white paint to warm it.

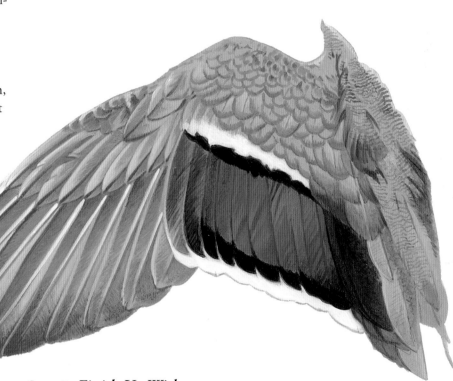

## STEP 3: *Finish Up With Lights and Darks*

This last step is to carefully paint the lightest and darkest areas of the wing. Use your dark values to accent some details and shadows. These values should be clearly darker than any in the previous steps, but do not have to be black. Continue building up a warm, bright white with additional layers of paint.

# Folded Wing on Female Mallard
## WATERCOLOR

Usually the side pocket feathers cover most of the speculum when the wing is folded. In this view, the primaries, speculum, and wing coverts are easily visible.

### MATERIALS

**Surface**
Arches 140-lb.
(300gsm) cold-
press watercolor
paper

**Paint**
Alizarin Crimson
Burnt Umber
Cadmium Orange
Cadmium Yellow
Pale
Cerulean Blue
French Ultramarine
Winsor Green
Winsor Red
Yellow Ochre

**Brushes**
no. 1 and no. 2
round sables

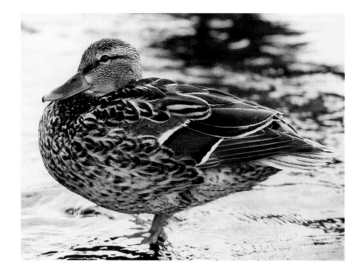

*Reference Photo*
Moments before this reference photo was shot, this hen had been sleeping with her head pointed back.

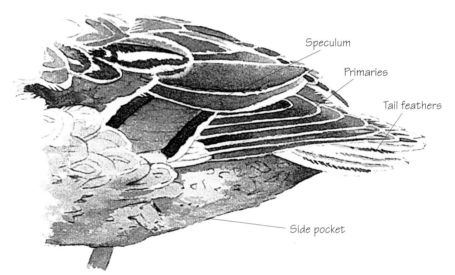

Speculum

Primaries

Tail feathers

Side pocket

## STEP 1: *Establish Basic Color*

Take a good look at your reference and decide what is the basic color for each area. Use light washes to indicate these areas and this will be your foundation to build on. Remember to protect those areas of light values, such as the white and buff-colored feather edges. This white is particularly striking above and below the color speculum.

Make sure you have a carefully planned layout drawing to guide you with your paint application. This will help you save the light areas. Where the body turns under and there is less light striking the feathers, you can wash these first light values to give that area a more solid color. This will be a base for the shadows.

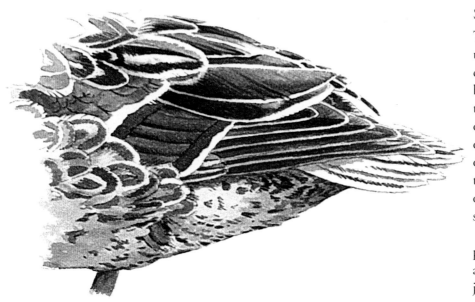

## STEP 2: *Apply the Middle Tones*

The next step is to use the middle values to establish both color and more detail. Some of these middle tones will be warmer, like those areas in the sun that are also more colorful. Add some of the warmer colors here, such as orange, yellow or ochre. On the shadow side they will be a bit cooler, a little bluer in value, like Cerulean Blue or French Ultramarine mixed with some Burnt Umber.

Use subtle washes to build your painting. At the same time, do not be afraid to use color and deeper values, just be sure to plan ahead. By building with the washes you can avoid too much paint in the wrong area.

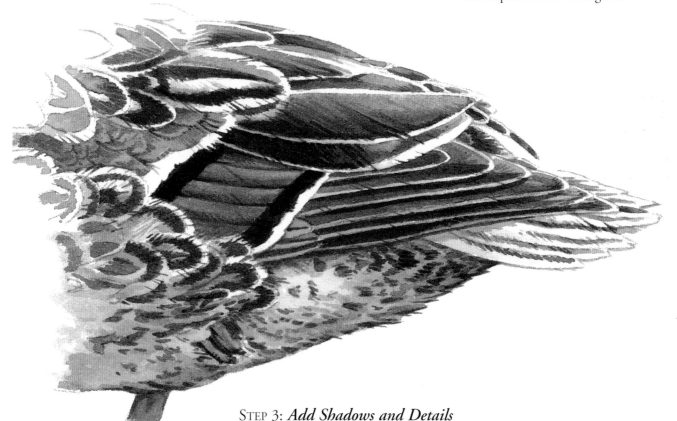

## STEP 3: *Add Shadows and Details*

Use washes to build up the darker areas, using the deeper tones to indicate shadows and details, such as the little separation breaks in individual feathers. Be careful not to overdo these breaks.

Use only as many detailed brushstrokes as needed to suggest the amount of detail you like. Sometimes less is more, the suggestion of detail is enough. We all have our own idea of how much detail we want to include. For this demo, the detail is concentrated around the speculum. Remember that you can direct the eye through the use of color and detail in your work. Did you notice the toes of the hen's left foot sticking out of the side pocket feathers?

# Side Pocket Feathers on Female Green-Winged Teal

OIL

This green-winged teal is facing away from us, perhaps preening. Part of her bright green speculum is showing. For this demonstration, concentrate on the small area of side pocket feathers, just under the speculum.

## MATERIALS

**Surface**
Stretched canvas

**Paint**
Burnt Umber
Cadmium Red
  Medium
Cadmium Yellow
  Light
Cerulean Blue
English Red Light
French Ultramarine
  Blue
Naples Yellow
White (Any type will
  work. I used
  Permalba White oil
  color.)

**Brush**
no. 1 round sable

**Other**
Painting medium:
  1 part stand oil/
  1 part damar
  varnish/5 parts
  pure gum spirit
  turpentine

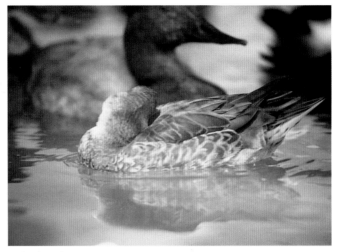

*Reference Photo*

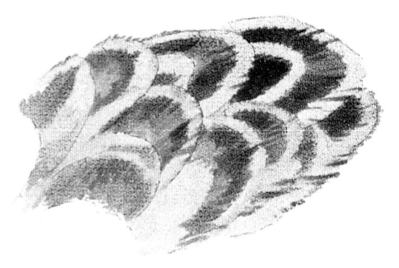

## STEP 1: *Block in Shapes*

Start with a thin solution of Burnt Umber and the painting medium. Paint this as if you were limited to only this for your paint, going dark and light as needed. The result will be a monochromatic painting. Be careful the paint does not become too thick in this early stage, as it will make it more difficult to add and manipulate more paint in the later steps.

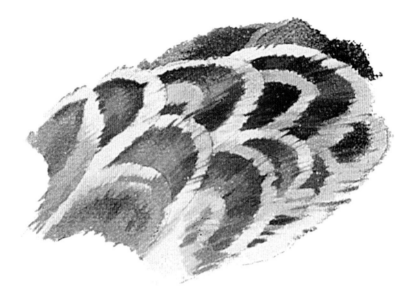

## Step 2: *Add Local Color*

Keep your paint thin and begin to apply the different color values to the feathers. Work carefully, and avoid too much paint or you may end up with a blending of colors. You do not want to end with a pile of "mud" instead of feathers! Look for the color variations, such as those two or three in the dark areas of the feathers. The light edges also vary if you look close. The advantage to the oil paint is that you can blend the areas of transition, such as the curvature of the individual colors, and drag paint with your round sable to suggest the feather splits and fraying. Hold back your final dark and light colors for step 3.

## Step 3: *Add Final Details*

If you are going to put a lot of detail into a painting, sometimes you reach a point with the oils that you just have to wait for them to dry. Then you apply the final lighter and darker color values over your other steps, without dragging or mixing with the other colors. You can use some color oil washes at this stage to pump more color intensity into areas that might need it. Some of the buff-colored feather edges could use such a wash and the leading edges need to be lightened with a white, tinted slightly with Naples Yellow or Cadmium Yellow Light to warm it. This last step is what makes these feathers look more three-dimensional and come to life. Remember that it is good to practice on small studies like this.

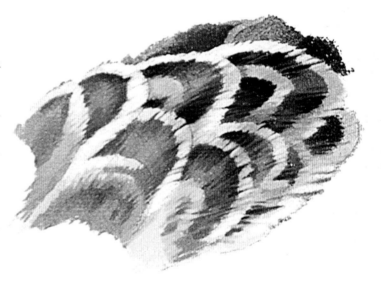

# White Feathers on White Ibis
## WATERCOLOR

This adult white ibis is walking the beach in search of food (immature ibis do not have the full white coloring). This demonstration is a good example of painting the effects of bright light on white feathers. The transition area between light and shadows is where the details are visible.

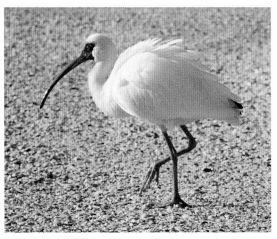
*Reference Photo*

### MATERIALS

**Surface**
Arches 140-lb.
  (300gsm) rough
  watercolor paper

**Paint**
Alizarin Crimson
Burnt Umber
Cadmium Orange
Cadmium Yellow
  Pale
Cerulean Blue
French Ultramarine
Winsor Green
Winsor Red
Yellow Ochre

**Brush**
no. 2 round sable

### STEP 1: *Protect the Whites and Paint the Shadows*

If ever the white, light areas of a painting are important, this is especially true on a white-bodied bird like this ibis. Mix three blue values, using the Cerulean Blue, French Ultramarine and a touch of green or yellow. Wet the major shadow area of the body and head and use these values to wash in the color. Keep that nice area of reflected light on the back of the neck and under the body. You may have to wet this area again slightly and either drag a brush through it or blot it with tissue to soften that section.

Continue with more washes, but add a bit of Burnt Umber to the mix, as the shadow under the chest and body appear a little muddier in color. Next, use the same approach with some orange and red values to paint the legs and bill. Do not paint on the white, light areas. You are strictly painting shadows. You can suggest some small details along the legs and feet.

I like the painting just like this. It has a good feeling of light, interesting shadows and colors. What do you think?

## STEP 2: *Develop Form*

Tie in the ruffled feathers on the back and begin some of the detail work. The colors on the bill and legs can be intensified a little with more red value and a slight orange wash along the edges where the light strikes. Leave some spots of white as highlights. As you work on the body details, make any adjustments you need for value and color in the shadows, like at the very bottom of the bird. Keep the area where the light and shadow meet soft and subdued.

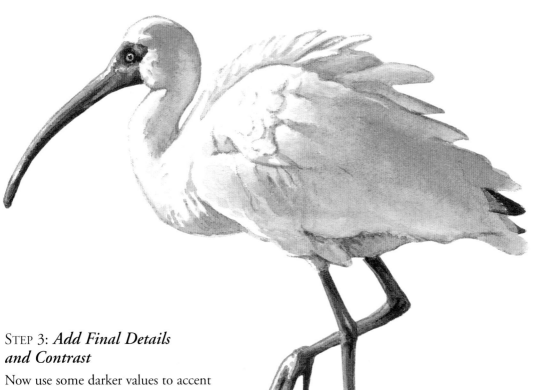

## STEP 3: *Add Final Details and Contrast*

Now use some darker values to accent the bill tip and eye area, as well as the legs. These are just slightly darker accents. Also paint the dark wing feathers just showing back toward the tail. You can add the shadow on the beach to further emphasize the low sun angle. A wash behind the bird would really set off the white areas, but I like it blending into the paper the way it is here.

# Mandarin Duck Head
ACRYLIC

This is the old-world counterpart to the more familiar wood duck. The mandarin is strikingly beautiful and a challenge to paint because of the colors and feather growth from the cheek area. The position of the head in the photo reference at middle right is a pleasing angle. However, the photo is not in focus.

The photo at top right shows some good details and colors for painting reference. You can see lighter pink details on the bill and get a better understanding of the mandarin's head. It might be helpful to have both photographs facing the same way. This makes them a little easier to relate to each other. If your reference photo is not facing the direction you need you might reverse the photograph's image through the use of a color copier, or by using a scanner and computer program.

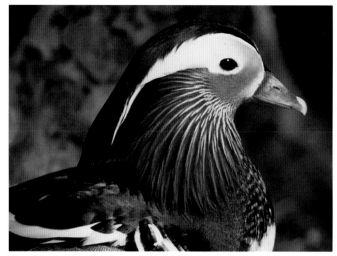

*Reference Photo for Coloring*

*Reference Photo for Pose*

MATERIALS

**Surface**
Strathmore 500
  Series bristol board

**Paint**
Alizarin Crimson
Burnt Umber
Cadmium Orange
Cadmium Yellow
  Pale
Cerulean Blue
Ultramarine Blue
Yellow Ochre

**Brushes**
no. 1 and no. 2
  round sables

STEP 1: *Light Washes*

Use light washes to begin defining the color areas of the head with the no. 2 round. Be careful to protect the white and light areas. Keep the paint values light, so you can build up the color and make any adjustments later with increasingly darker values.

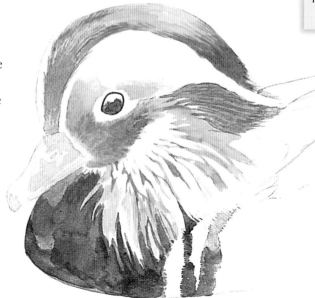

## STEP 2: *Develop Form*

The mandarin's head is very complex and it is important to slowly develop all the intricate areas, protecting those light-colored areas. Anytime you need more control, switch to the no. 1 round. Use yellow and ochre for the cheek area, crimson and orange in the long feathers coming off the cheek. Use Ultramarine Blue and umber for dark values. The subtle blending of all these is what gives you the feeling of form. Use your darker values for shadows and begin to suggest some details of the head. Save the darkest values for the next step.

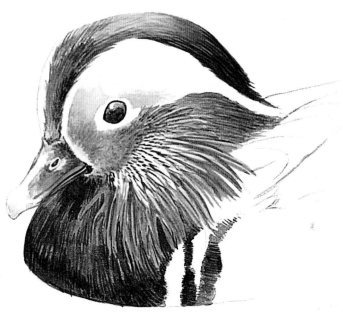

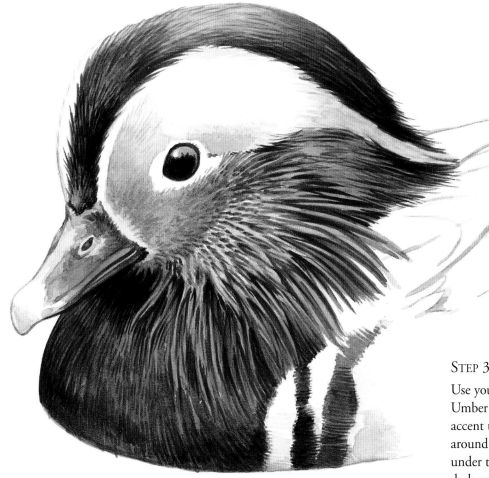

## STEP 3: *Add Dark Values*

Use your darkest values of Burnt Umber and Ultramarine Blue to accent the shadows under the head, around the eye and bill area, and under the long feathered cheek. These dark colors should be used to accentuate the duck's head and shape. They will give added depth and contrast, helping you bring your painting to life!

# Redhead Duck Head

OIL

Sometimes your reference photos, or even mounted specimens, might not be the color that you want for your painting.

The redhead drake photo taken in black and white is a good example. If you have a bad reference, do some research and look for other photos that will give you the correct color that you want to see in your picture.

Photos are only a guide, and rarely can be relied on alone for all your reference needs. I usually use many photos for my paintings, some for details, some for color, others for shadows, and so on.

*Reference Photo for Pose*
This drake appears to be frightened or alert, as his head feathers are pulled tight and compressed.

*Reference Photo for Coloring*
This drake was relaxed and had been sleeping. The weather was cold that day and his head feathers are fluffed up and make his head appear larger.

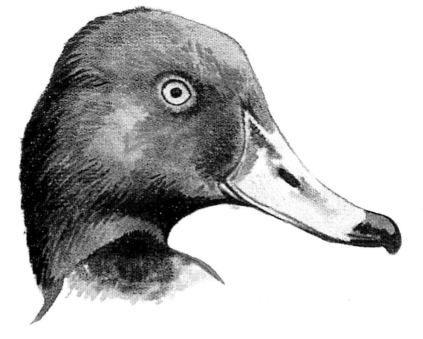

## STEP 1: *Apply Main Color*

The main color of the drake's head is just what you would expect—red. If you find your base color is too red, try adjusting it with Burnt Umber and Cerulean or French Ultramarine Blue. Paint the entire head this color, except for the eye, bill and chest area. With this same middle-value concept, paint the bill the middle value of the blue color and the same with the eye. Do not forget the tip of the bill section. Let dry.

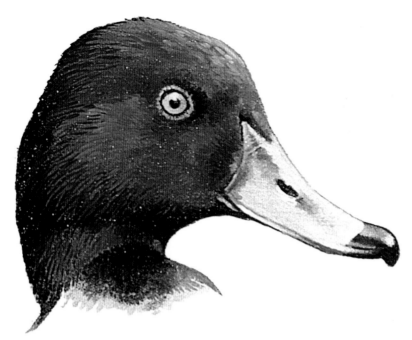

## STEP 2: *Add Middle Tones*

For simplicity, let us assume that the colors here in the drake's head, like the red, have a range of five color values. You have used number three, the middle value as your base color. Now use the darker value, number four, to add some shadows and details. Also use the next lighter value, number two, to suggest areas where the light is striking the head. There should be some variations in colors, but these few values are to get the point across. Limit yourself to these values and then wash any extra color washes over them that you need. In my example, I have done this on the bill and head, working from right to left.

## STEP 3: *Lay Final Values*

This is where you use values one and five, the lightest and darkest of the color values. These can be the most fun to use, as they are what make the image pop and give the head a more three-dimensional look. Start with thin washes of these values to slowly build the changes. Use the darkest value, a French Ultramarine Blue and Burnt Umber mix, and accent the dark areas of the bill tip and base. Use this also on the pupil and neck shadows. For the lightest value, use white tinted with Cadmium Yellow Light, and apply this on the highlights to the top of the head. Paint some orangish color as a few strokes in the head and neck to provide a little more color. The absolute dark and light values are your last resort to really make an impact. In a moody, foggy picture, these values may be quite subdued and far from the values you are using here.

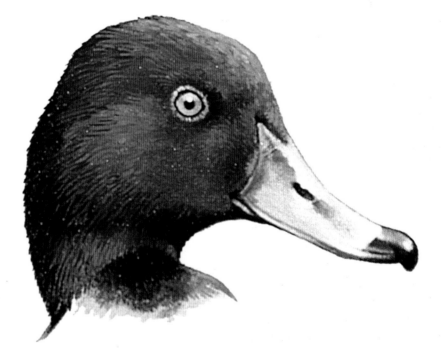

# Ruddy Turnstone Breeding Colors
## ACRYLIC

This demonstration shows how you can change a bird's plumage by combining information from your reference photo with other reference sources, such as other photographs, bird books or field guides.

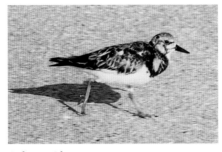

*Reference Photo*
This ruddy turnstone is in winter plumage, having a mottled, ill-defined patterning. The breeding plumage for this bird is much more colorful and has a more pronounced pattern. Use this photo as reference for details and feathers, but use the illustration at right as the basic color pattern to show your bird in breeding plumage.

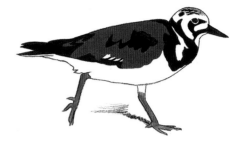

*Breeding Plumage*

### MATERIALS

**Surface**
Solid Ground polymer panel

**Paint**
Burnt Sienna
Burnt Umber
Cadmium Orange
Cadmium Yellow
  Medium
Cerulean Blue
Quinacridone Violet
Titanium White
Ultramarine Blue
Yellow Ochre

**Brushes**
no. 1, no. 2 and no. 3 round sables

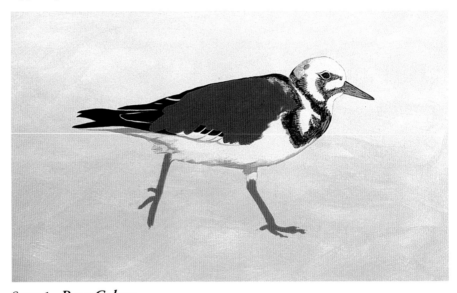

## STEP 1: *Base Colors*

To begin this painting, start with a base color for the entire painting surface. Try to mix a color that approximates the overall tone and value of your setting, which in this case is the beach. It may take three or four applications to get a good, fairly opaque basecoat. Use a transfer sheet made from your layout drawing to transfer the image of the turnstone back over the base layer of paint. Transfer only the main color patterns of the bird to get started.

## Step 2: *Establish the Feather Pattern*

Continue working with your three base colors, the dark, the reddish brown feather color, and the leg color. At this stage, the white of the bird can remain the same as your background color. Add a fourth color to represent the shadow along the neck and belly of the turnstone. It will take several layers of paint to build up the color areas so that you have an opaque area to work with. Keep the edges irregular where the pattern is more broken, such as the head and chest area. Use the no. 2 or 3 brush and medium values so you can work both darker and lighter values into these blocks of color.

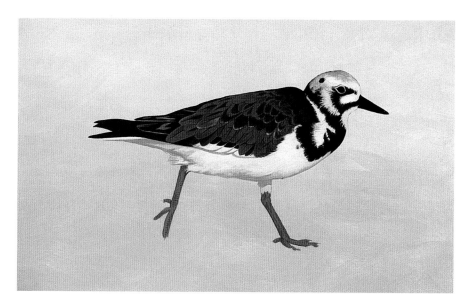

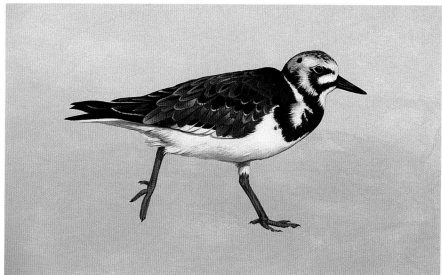

## Step 3: *Add Details to Feather Pattern*

Establish the feather placements on the side and tail areas. Use Burnt Sienna to paint the feather shapes and suggest some details and shading of individual feathers. On the long feathers near the tail, use a lighter mix of white, Yellow Ochre and Burnt Umber to paint in the lighter markings.

After several coats of the lighter paint, glaze Burnt Sienna over these areas to get the correct color intensity. Using the middle value of your dark value, refine the pattern edges in the head and chest. Then work on the feathers that will be the dark patterns in the side.

Mix a slightly lighter value of your background color, tinted with a little yellow and Burnt Umber, and use this to slightly increase the lighter areas of the body and head. Use a few washes on the head to indicate the tan coloration on the top and sides. The feet should be a darker orange/red than the reference photograph suggests, because of the change that occurs with the breeding coloration. Use a darker value to indicate the details and form for the legs.

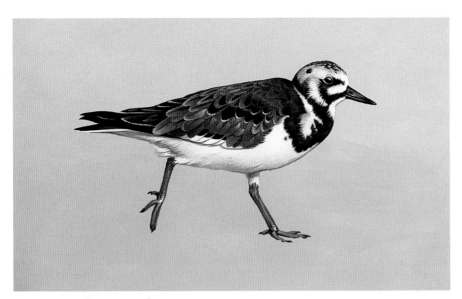

## STEP 4: *Refine Details*

At this point you have the color pattern, the feather pattern and suggestions of shadow, light and some details. Now it is time to refine and embellish these details. The reddish brown feathers are a good place to start. Switch to a no. 1 round for this work.

Keep working both darker and lighter on these feathers. The lighter areas are on the top as the feathers curve toward the top of the body and on some of the light feather edges. The darker values are on the shadows and are used to enhance the feather shapes.

Paint the legs and feet in the same manner, keeping the changes subtle and not too dark or too light.

Continue with this same process of working a little darker and then a little lighter on both the dark patterns and the white body parts. Use some of a dark paint value to accent the brown feathers and some of the paint for the shadow. Use the light paint of the white body to accent feather edges. Keep the shadows of the body keyed in color to the beach colors. This sand-and-shell ground bounces light up onto the bird and affects the color that you see. Use several washes of darker paint to suggest the pattern markings on the top of the head.

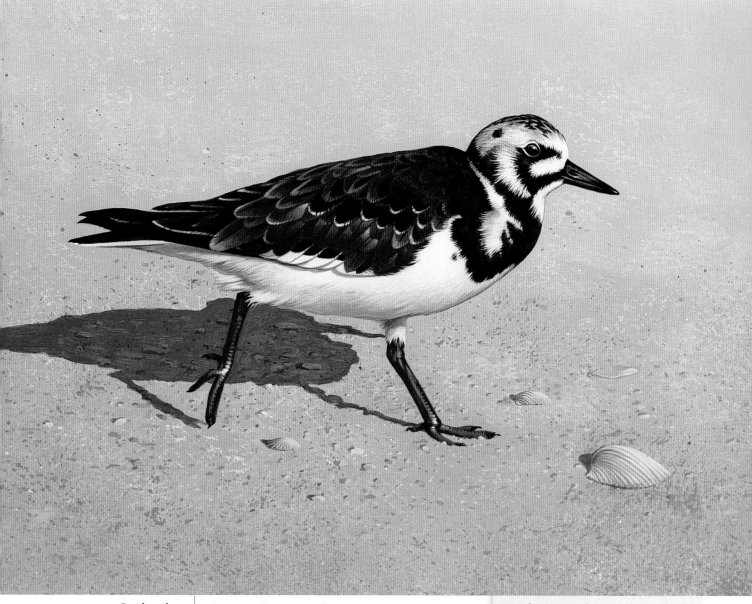

*Beachcomber*
Acrylic on panel
7" × 15" (18cm × 38cm)
Collection of the artist

## STEP 5: *Increase Contrasts*

The turnstone looks good, but lacks the contrast that will bring it to life. To increase this contrast, paint a mixture of Ultramarine Blue and Burnt Umber to accent all the areas that are to be "black." Work on the details of the side feathers and on the markings of the head and chest. The head, including the bill and eye, is crucial to bringing the painting to life.

Work with your lightest values for the head and body. Use these as if you were applying sunlight on a real bird. Keep the "white" on the warm side, perhaps with a slight yellow/green tint to correspond with the beach and give a "live" and warm feeling. Finally, use some lighter values of the "black" to accent the areas of dark feathers, the eye and bill that would reflect the light on their upper surface.

## Background

The bird is now finished. What he really needs now is a cast shadow that will place him on the ground and help establish the direction of the light and the plane of the ground he is walking on. It adds to the illusion of a three-dimensional form.

Try using some different techniques for the sand-and-shell beach. It is quite a busy area of tiny specks. Using a combination of sponges, splattering and stippling works well. Pick out a few shapes to cast more shadows, and put in some individual shells to help convince the viewer that this is a beach and give the eye details to focus on.

# 5

## PAINTING WADING BIRDS
### step by step

The demonstrations in this chapter take a simple approach to painting, focusing on painting the bird itself, followed by some ideas on how to place that bird into a background, should you wish to take the painting further.

*Great Egret*
Acrylic
7" × 11" (18cm × 28cm)
Collection of Mr. and Mrs.
Lester P. Lawrence

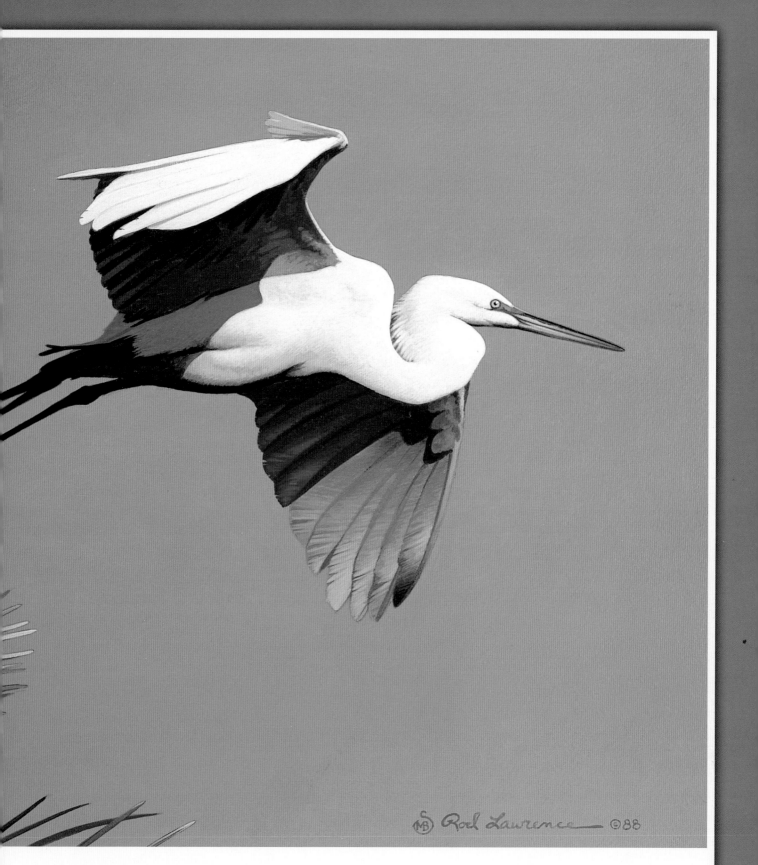

Rod Lawrence ©88

# Willet in Winter Plumage
## WATERCOLOR

The willet is most distinctive when seen in flight. It has a striking black-and-white pattern on its wings. The willet in this demonstration is showing just the last few wing primaries with this pattern.

Before you can get started painting, you need to plan and prepare for it.

Gather your references, sketch various angles of your subject. Flip-flop your drawings and photos for different effects. Change the tilt of the head or body, or change the feet. Use your proverbial "artistic license" to come up with a composition you like.

*Reference Photo*

### MATERIALS

**Surface**
Arches 300-lb.
  (640gsm) hot-press
  watercolor paper

**Paint**
Alizarin Crimson
Burnt Umber
Cadmium Orange
Cadmium Yellow
  Pale
Cerulean Blue
French Ultramarine
Winsor Green
Winsor Red
Yellow Ochre

**Brush**
no. 2 round sable

### STEP 1: *Layout Drawing*

The layout drawing will help you understand and interpret the reference photograph. There are a lot of feathers here and it is very helpful to have most of them planned in advance.

Once you are comfortable with your layout drawing, transfer it to your watercolor paper. You can refer to the layout drawing if you lose your drawing with some of the color washes in the painting process.

## STEP 2: *Lay Simple Washes*

Use light-value washes to paint the broad areas. Where you can see a change in color and value, such as the area above the eye and extending around the back of the ear and neck, mix several values and blend them with your wash. Keep the values light and work carefully. As a rule, use the warmer colors, like yellow, orange and red on the areas in sunlight, and the blues and brown in the shadows. Indicate a few general details, such as around the tail and under the belly, but don't get carried away with doing too much.

## STEP 3: *Refine the Washes*

In this step, work the broad areas into the individual feathers. Use some slightly darker washes to accent each feather. Use the reference photo for help, but also your own sense of light and shadow. You can see by the highlight in the eye and the shadows under the neck, belly and legs just where the sun is. Build your painting carefully, darkening as you go. This is the longest step in terms of working time. Once again, do not go too dark and do not put in too much detail. Concentrate on the feather shape and blending, not the individual feather breaks.

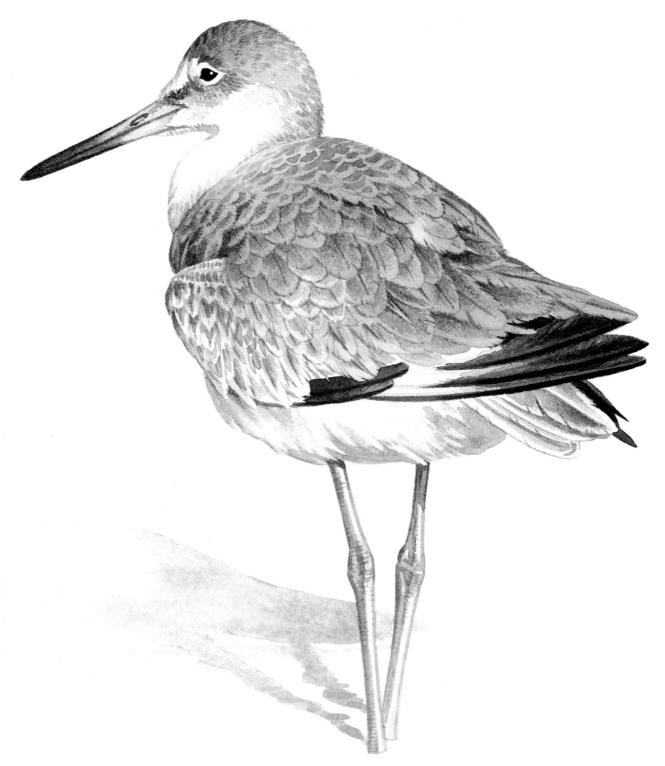

## STEP 4: *Add Final Details*

It is the final touches that make all your hard work come together. Use darker values, still building slowly, and start adding details like the feather breaks and the darker accents on the wings and bill. Give a suggestion of leg texture with a few small horizontal lines coming from the shadows toward the light side. Increase the shadow on the legs from the body a bit for impact. Add some bluish washes using Cerulean Blue along the shadow side of the bird, from the neck down to help emphasize his form. Finally, he needs that spot of light in the eye. That is the final spark of life for this willet. You can either scratch it out of the dark area if you want to be more traditional, or you can "cheat" and add a dab of gouache or acrylic white paint. A light bluish wash for his shadow adds a little space behind the bird. All done!

# Placing the Willet Into a Background

Work with different reference photos to place your willet into an environment. Doing thumbnail sketches will help you develop ideas for your painting composition.

The reference at left has been cropped here for a tighter composition.

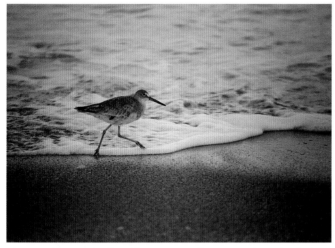

This is a photograph of a willet in winter plumage searching for food along the beach. The composition of this photo is good, but the open space around the bird suggests some ways to crop the image.

Both references are combined here. The subject in action is more prominent against the active background.

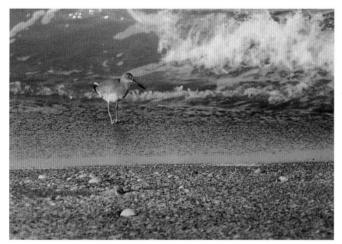

This willet has more wave action behind him, which seems to draw attention away from the motionless subject.

Try flipping your sketches for different effects.

# Flying White Ibis
## OIL

Quite often flying bird references turn out blurry, making it difficult to see individual feathers and wing tips. This demonstration will help you create a detailed flying ibis from an out-of-focus reference. An understanding of bird anatomy really helps in these situations.

### MATERIALS

**Surface**
Stretched canvas

**Paint**
Burnt Umber
Cadmium Red
    Medium
Cadmium Yellow
    Light
Cerulean Blue
English Red Light
French Ultramarine
    Blue
Naples Yellow
White (Any type will
    work. I used
    Permalba White oil
    color.)

**Brush**
no. 1 round sable

**Other**
Medium: 1 part
    stand oil/1 part
    damar varnish/
    5 parts pure gum
    spirit turpentine

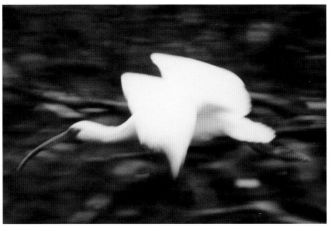

*Reference Photo*
Use this reference for the shape of the flying ibis. Gathering additional reference will help you add sharper details to your painting.

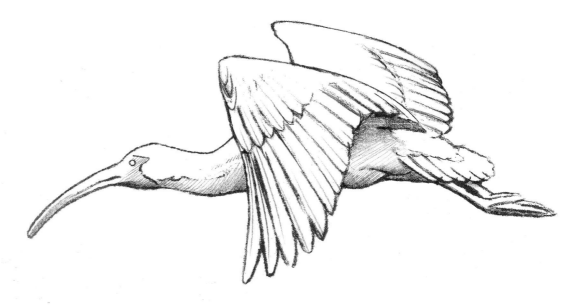

### STEP 1: *Layout Drawing*

Once you find some photos to help you, do a layout drawing and make the wings complete. Even if you are going to paint them very detailed or very blurry, it is important to know the basic structure and where the primaries are located. Transfer the drawing to your stretched canvas.

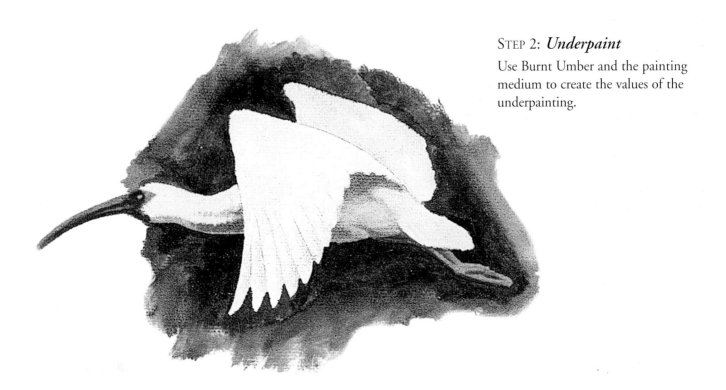

## STEP 2: *Underpaint*

Use Burnt Umber and the painting medium to create the values of the underpainting.

## STEP 3: *Add Local Color*

Mix an off-white color using a touch of Cerulean Blue and Burnt Umber as the lightest value on the ibis. Mix several darker values of this same color as the shadows on the body and wings. Some small areas appear greener, so add a touch of Cadmium Yellow Light as necessary. The shadow under the wing has a warmer glow; mix less blue, with more yellow and umber. Paint these values on thin and blend to soften the transition between light and shadow.

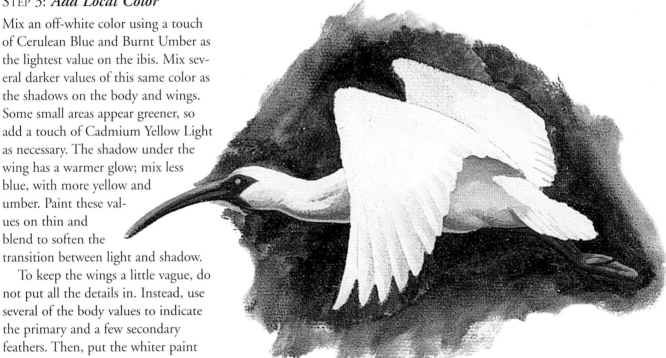

To keep the wings a little vague, do not put all the details in. Instead, use several of the body values to indicate the primary and a few secondary feathers. Then, put the whiter paint down the leading edge of the feathers. Now blend them together somewhat, starting from the top down until you get the desired effect. Follow similar procedures for the face, bill and feet. When this has set awhile, move on to the next step.

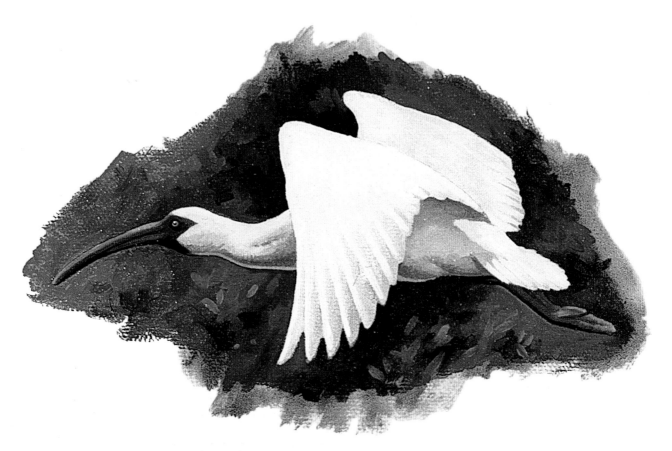

## STEP 4: *Final Touches*

The last step involves using the final darkest and lightest values. It is also the time to do any touch-up work and details. Now you can work over some details and drag the underpainting along with your strokes—providing that you work with thin paint and do not put a lot of pressure on the brush.

Use the red colors to refine the head and feet. Touch up the highlights now too. The biggest area to finish here is the white of the wings and the top surface of the head, neck and tail. Use white, but tint it just slightly with a little dab of Cadmium Yellow Light or Naples Yellow to give the white a warm glow. A few strokes down the tail and on the leading edge of the primary feathers will set them off. After you paint the upper wing surface, blend the primary shadows into the wing as much as you want. You could make them more detailed, or more blurry. To see the final effect better and see how this would look in a full background painting, simulate some green foliage around the bird, similar to the reference photo. Don't forget the highlight in the eye.

# Placing the Ibis Into a Background

When placing a bird into a background, the scene has to be accurate. Here, both photos were taken on the same river, on the same day, only a few hundred yards apart.

The lighting in this background setting will really help to set off the white bird.

Here again is the ibis flying reference.

Trace the ibis shape from the reference onto a piece of tracing paper and slide it around to see how he looks in different parts of the composition. He could be larger or smaller, depending on how close or distant you want him to appear in the picture plane.

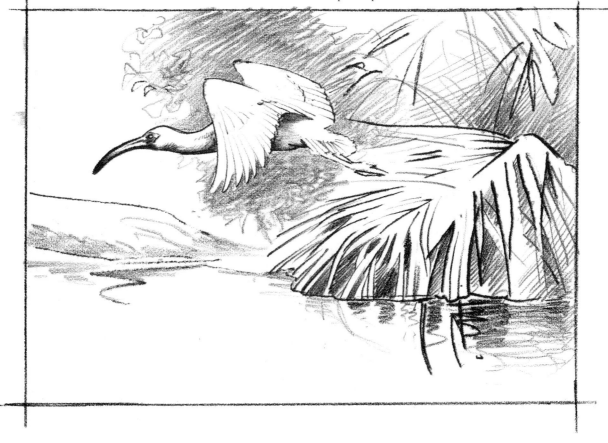

# Great Blue Heron
ACRYLIC

By placing this heron alone against a plain, blue sky background we can concentrate on the bird. Herons have interesting feather patterns, as well as a variety of feather types and textures.

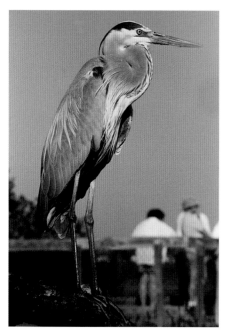

*Reference Photo*

MATERIALS

**Surface**
Solid Ground poly-
mer panel

**Paint**
Burnt Umber
Cadmium Orange
Cadmium Yellow
  Medium
Cerulean Blue
Quinacridone Violet
Titanium White
Ultramarine Blue
Yellow Ochre

**Brushes**
no. 1 and no. 2
  round sables

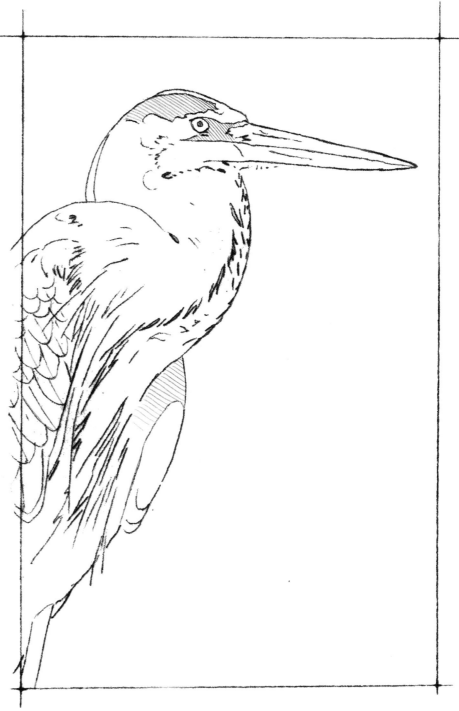

STEP 1: *Layout Drawing*

This drawing is a bit complex, but there are a lot of details in this heron image.

  When complete, transfer your drawing to the panel.

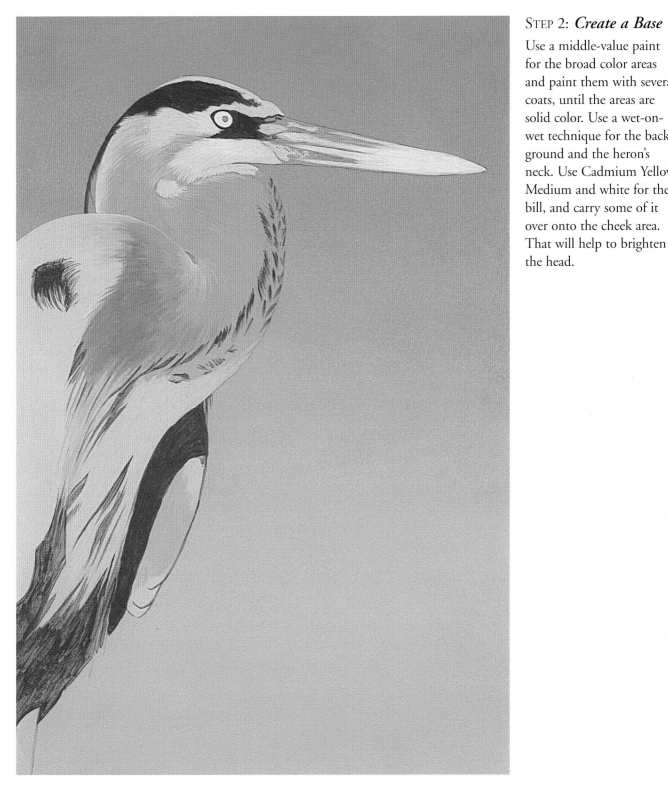

## STEP 2: *Create a Base*

Use a middle-value paint for the broad color areas and paint them with several coats, until the areas are solid color. Use a wet-on-wet technique for the background and the heron's neck. Use Cadmium Yellow Medium and white for the bill, and carry some of it over onto the cheek area. That will help to brighten the head.

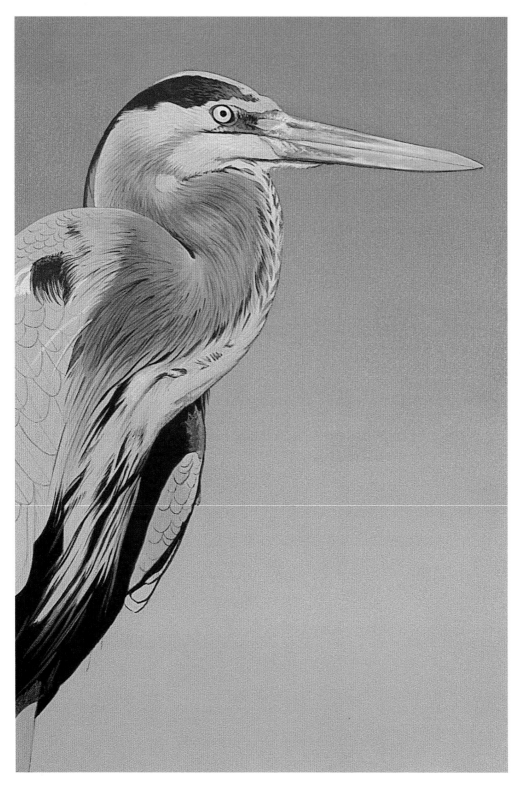

## Step 3: *Develop Form*

Now use the transfer sheet to transfer some of the details (especially areas such as the feather patterns on the wings and the chest feathers) from your layout drawing back over the colored areas.

Blend the blocked-in color areas with slightly darker and then lighter values. Take your time, building the detail and transitions between areas. The goal here is to establish a three-dimensional look to the heron, but to keep the values subdued. All the main patterns, shadows and highlight should be established. The painting is now a detailed base to build the rest of the heron. Work in some more color on the neck, like the reddish brown, and also strengthen the intensity of the yellow on the beak.

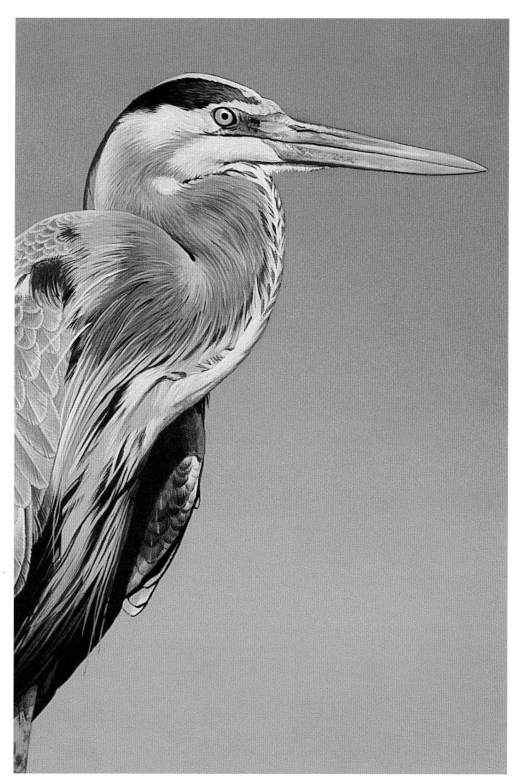

## STEP 4: *Establish the Feathers*

Paint the feathers on the shoulder of the wing, starting slowly with subdued values. In this step these feathers shown are painted with only two or three values over the basecoat. By varying the amount of water for thick and thin washes, the values can change gradually. Continue working with darker and lighter paint values, but remember to save several of the lightest and darkest values for later.

The heron looks quite good at this point. The direction of light is obvious from the shadows and bright areas, and there is quite a bit of detail. But he is only about 50 percent alive at this point!

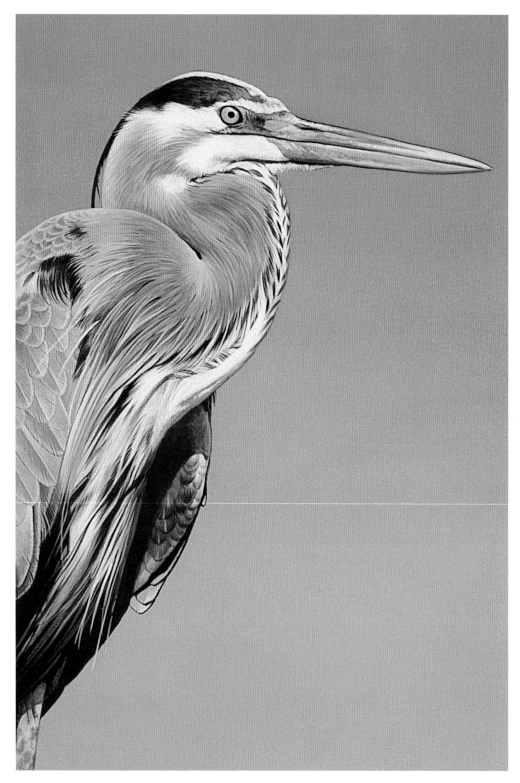

## STEP 5: *Work With Light*

The dark values seem to be more pronounced than the light, so begin with a lighter value of "white." Use this as if you were painting actual light onto the heron's shape. Build with glazes and make the areas in the strongest light more opaque, such as the head and neck. There are also some other areas that need work, both lighter and darker, such as the beak. Build up some colors as well as the value changes. Don't be afraid to add some Cadmium Orange, Burnt Umber or even violet to the yellow paint for the bill. These give a variation of color and intensity that works well on the bill. Add some greener-blue highlights to the dark area on the top of the head here too. This heron is starting to "pop" and stand away from the background on his own!

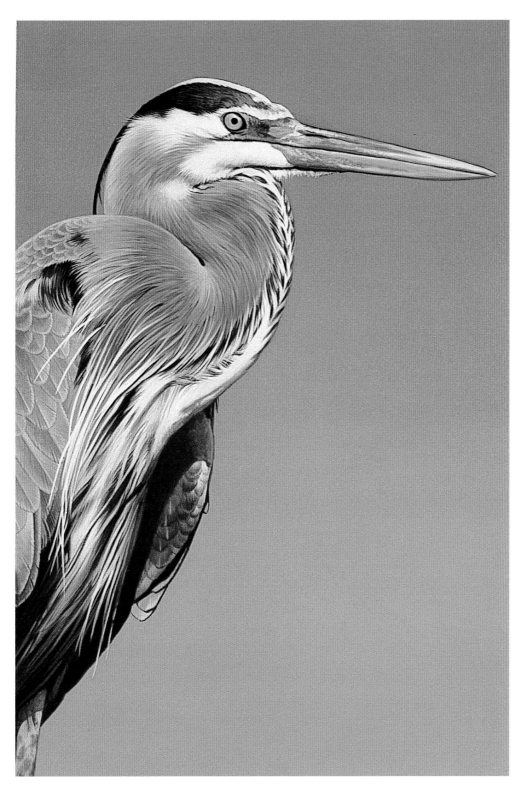

## STEP 6: *Add More Light*

Now that the head and neck light areas have intensified, the rest of the heron can use a touch of the same idea. Refer to the reference and also consider what you think needs some additional light. Use a few glazes and sharpen some of the light details and bring the body back into balance with the rest of the bird. However, the head and neck are still important, especially the head, so continue to build these white areas up again, tinting the white with Cadmium Yellow Medium. Don't forget the highlights on the bill and eye. Each little area needs refinement as you work.

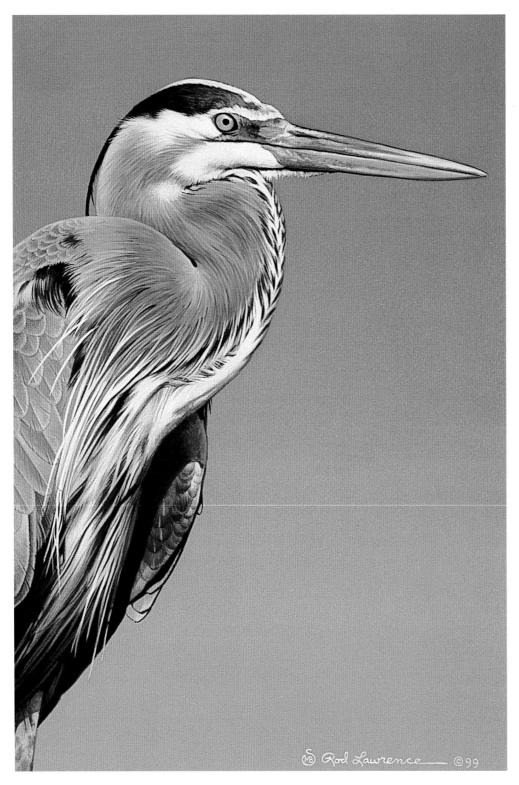

## STEP 7: *Add Final Touches*

There is still one more thing to make the heron really stand out. The darkest value has not been used yet. By mixing Burnt Umber and Ultramarine Blue you can get a nice dark color, but something that is not just plain black. Use enough Ultramarine Blue to keep the color more toward a blue color than brown. Now use this mix with care and again build with a few washes. This final dark will be the darkest contrast and help set off the head and lower body shadows. See the difference between the look in this step and that of step 6? The heron looks more prominent and stands out away from the background.

# Placing the Heron Into a Background

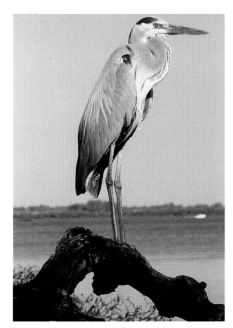

This background photograph has good tree root forms and nice strong lighting.

This pose is good; the light comes across the heron's body, making some nice shadows on the right side.

The great blue heron reference lends itself well to placing him right on one of the mangrove roots, without having to make any anatomical changes to his photo reference. However, the lighting on the heron will have to be changed to the harsher overhead light that you see in the background photo. That will tie him to the picture and also make him stand out against the dark background just like the root system does.

# 6

# PAINTING WATERFOWL
## step by step

This chapter starts with a simpler painting process, and then proceeds with more complicated compositions where everything comes together: the thumbnail sketches, the layout drawings, the photographic reference and the painting process itself. The demonstrations in this chapter include some background and foreground elements, placing the waterfowl in typical environments.

*Mallards in the Mist*
Gouache
16" × 20" (41cm × 51cm)
Private collection

Rod Lawrence ©1981

# Ruddy Duck on the Water
## ACRYLIC

This demonstration will help you place your subject in an intricate, rippled water setting. Water can be quite difficult and, like most subjects, good reference and practice is very helpful.

### MATERIALS

**Surface**
Solid Ground polymer panel

**Paint**
Burnt Umber
Cadmium Barium
Red Deep
Cadmium Orange
Cadmium Yellow
Medium
Cerulean Blue
Quinacridone Violet
Titanium White
Ultramarine Blue
Yellow Ochre

**Brushes**
no. 1 and no. 2
round sables
1-inch (25mm) flat

This image is slightly fuzzy and a little bit washed out. But the duck's position, the water reflection and the ripples will work well for a painting. In finishing the painting, you may wish to rely on other reference for details, including the eye placement and feather coloring.

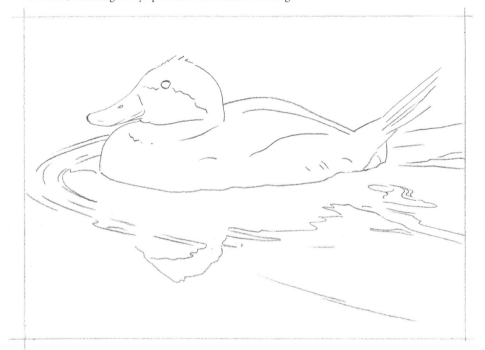

### STEP 1: *Layout Drawing*

Use your layout drawing to decide your composition and any major elements that will be in the painting. In this case, the only major elements are the duck, the reflection and the water action.

After your drawing is complete, transfer it onto your painting surface.

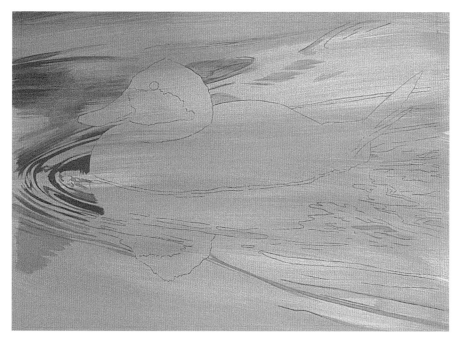

## STEP 2: *Paint the Water*

Mix several values that are in the middle tone range of the water. Apply them using a wet-on-wet technique and blend them with your flat brush. This may take several coats.

When this is dry, mix a similar color, but one that is somewhat darker than the midtone colors you used earlier. Use Cerulean Blue and Burnt Umber to darken the color, but be careful not to make it too dark. Keep this paint thin and apply some washes to suggest darker areas of water and some of the ripples. You can use the same paint and get different values with it by starting with watery washes and then more paint with less water. It will help in making a subtle transition in the water and help give it a smooth look.

Use a lighter value, such as white tinted with Cerulean Blue and maybe a dab of Yellow Ochre, to build areas of light reflecting on the surface of the water. The water should begin to have a solid, but watery feeling to it. Keep yourself from going too light with the values here.

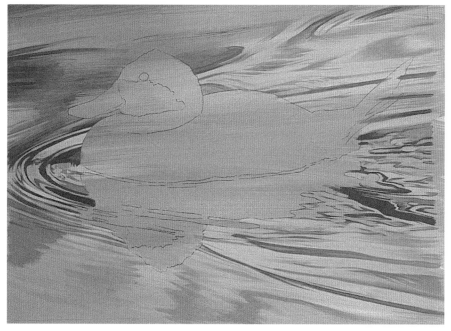

## STEP 3: *Add Duck's Reflection*

Continue working on the water and gradually lighten the areas that are reflecting the most light. Now you can start using some of the colors on the duck's reflection. Keep the values somewhat subdued, but you will need to add some of the muted color reflecting the body colors.

Sometimes it is better to wait on the reflection until the actual duck is blocked in. However, the reference here is quite good and you can work on the water image with some confidence. The water now looks like it has a good surface and the reflection of the duck adds to the effect. As you work on both the reflection and ripples, remember the ripple shapes and the effect they have on the reflections.

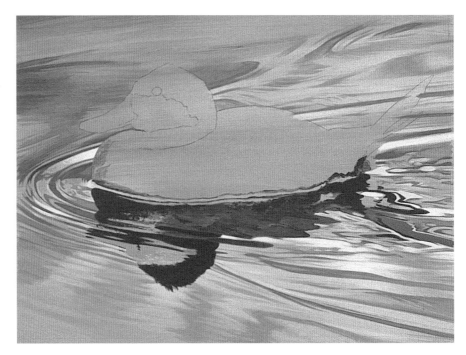

## STEP 4: *Add More Color to the Reflection*

Paint the blue of the bill reflection and darken the areas of the reflection that are the darkest areas of the duck, such as the head, chest and tail. Use some lighter and darker values in the ruddy's cheek and body area of the reflection. Keep all the values somewhat muted, with Burnt Umber and Cerulean Blue, or Ultramarine Blue. This helps the "real" bird look more alive and also helps the separation of the bird and its reflection.

The water should look pretty good now. With all this work on the water, chances are you have painted over some of your drawing. Use your layout drawing to get his image back on the painting now and move on to the next step.

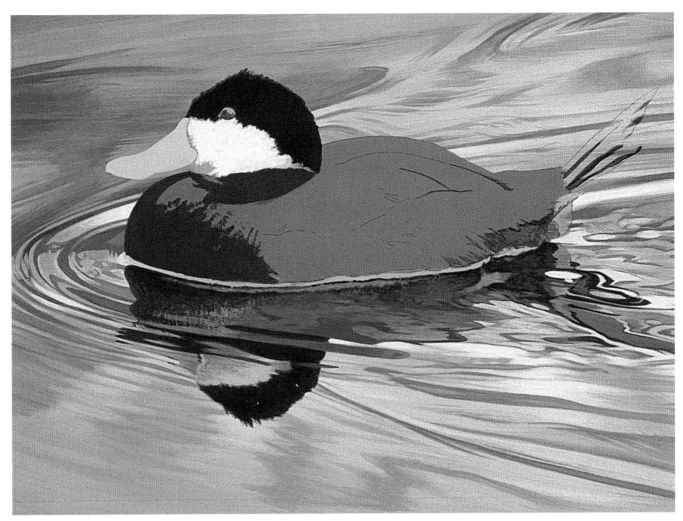

## STEP 5: *Paint the Duck's Body*

Think of the ruddy's body as simple color shapes. Squint your eyes and try to see what the middle value would be for each of these areas. Paint these areas, which may take several coats of paint, until you have an opaque area to work with.

Use lighter values to show where the eye is and darker values to show major shadows. These will be helpful guides as you work. Reestablish any lines from your drawing as needed.

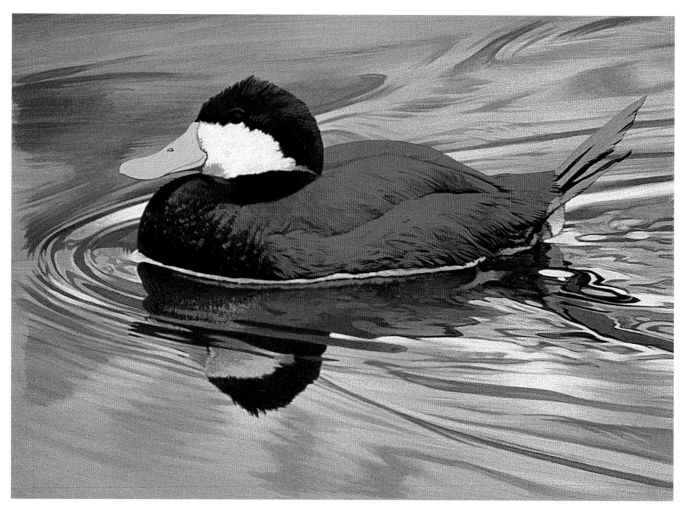

## STEP 6: *Add Darker Details*

Use darker values and colors to suggest the feather details
and shadows. This will begin to sculpt the duck's body and
make it look round. Once you have done this, you can
start adding slightly lighter values to areas as needed, such
as the top of the head. Mix your strokes so that you use
subtle washes in some places, bolder accents in others to
get the effect you want. Your darker and lighter values
should noticeably contrast with those in the reflection. This
contrast makes the real bird look more alive and important.

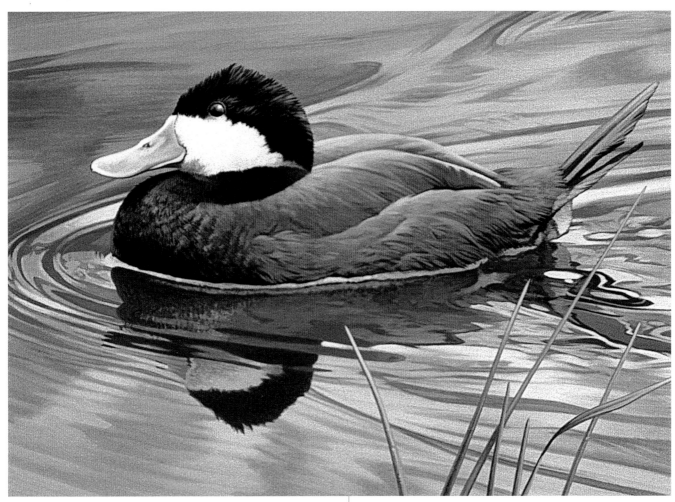

## STEP 7: *Final Touches*

Continue adding darker and lighter values of color. Do not add just white to get your lighter values. Keep them looking lively with some yellow hue color, such as an ochre.

The same is true for the dark values. Try mixing Ultramarine Blue, Burnt Umber and a touch of Quinacridone Violet or Cadmium Barium Red Deep to get your blacks.

Sometimes the sky reflects in a soft haze on the top of birds and animals. Paint in this effect on the ruddy's breast, to the top of his back and around the head.

After much consideration, I decided I just had to put something in the lower right corner of my picture. Some small spring growth is a nice compliment to the reddish brown of the duck body. Add just enough to accent the painting.

*Ruddy Duck*
Acrylic on panel
7" × 10" (18cm × 25cm)
Collection of the artist

# A Pair of Northern Shovelers
## ACRYLIC

This demonstration gives you the opportunity to study and reproduce the intricate feather patterns of these birds. These ducks are unusual among waterfowl with their broad spoon-shaped beak.

Using a close-up view of this pair in the water gives this painting a tranquil setting, and the cattails help create interest and depth.

*Drake*
The angle of the drake, water ripples and reflections make this a good reference.

*Female Shoveler*

MATERIALS

**Surface**
Solid Ground polymer panel

**Paint**
Burnt Umber
Cadmium Orange
Cadmium Yellow
  Medium
Cerulean Blue
Quinacridone Violet
Titanium White
Ultramarine Blue
Yellow Ochre

**Brushes**
no. 1 and no. 2
  round sables
¾-inch (19mm) flat

*Cattail Reference*

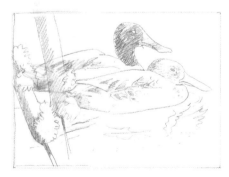

*Sketch With Cattails*

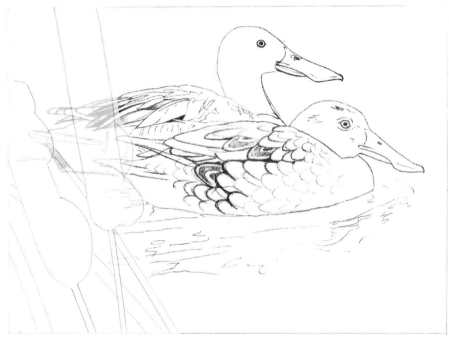

## STEP 1: *Layout Drawing*

Draw in the ducks' major feathers, including some patterns. You will also want to add the primary feathers. By running one of the cattails off the top of the page, it makes a strong line that leads the eye back to the ducks.

As a line drawing, the back of the hen and the side of the drake blend together, making things a bit confusing. This problem will have to be solved through color values and lighting.

## STEP 2: *Paint the Background*

When you get down low to the water's surface and look out, sometimes the surface gets lighter as it recedes toward the horizon. That is the look for this background, which should get lighter and bluer as it moves from the bottom to the top of the panel.

Mix three or more piles of paint in the value and color that you want for this background. Make sure the paint is thin, so it will flow easily. Apply them in rows, either working from top to bottom or bottom to top with your ¾-inch (19mm) flat. Work quickly, blending between each color and value change. You may need to apply paint over the first application. More often than not, I have to do this several times—sometimes a half-dozen times!

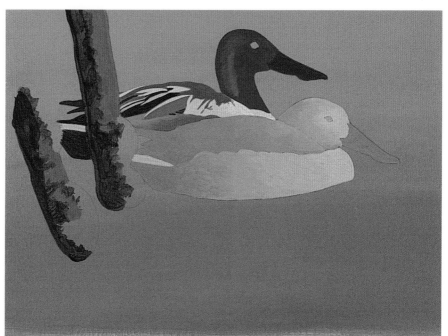

## STEP 3: *Block in the Birds*

Transfer the major basic shapes from the layout drawing to the painting once the background is dry.

There are two methods used in this block-in phase. One is a simple, one-color application like you see on the back and bill of the drake. It is the medium value of that particular area. A variation of this is the cattails, where two color applications are used, one for the shadow area and one for the sunlit area. The other method is a blended application, like the background. This works well on the side of the hen, where the light and shadow blend around her curved side. On this area, the medium value is based on the light edges of the side feathers.

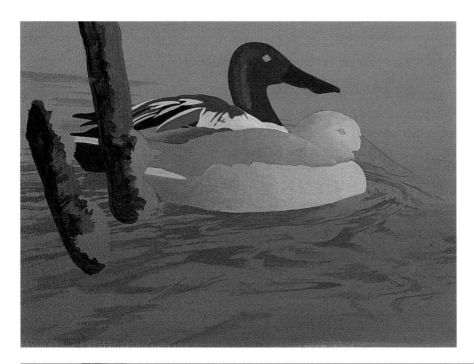

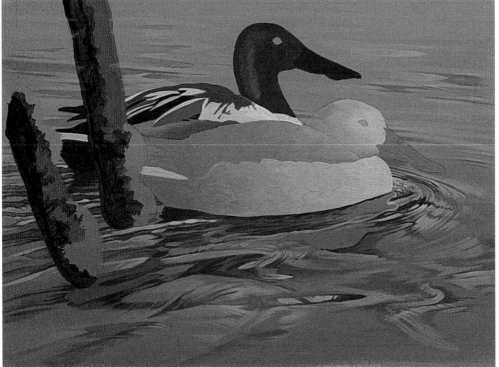

## STEP 4: *Block in the Water*

With the ducks blocked in, you can visualize the picture in color now and they serve as a guide to see how you might want to adjust the water to the best advantage. Start with thin washes and slightly darker values. Refer to the reference photo and begin to paint the reflections and ripples. Vary the values with thicker and thinner washes, and build up these areas as you paint.

As you build up the water, add darker values and colors, in both the ripples and reflections. As those take shape, add some lighter values and color that represent the reflection of light on the surface. Again, work with thin washes and build these areas up. You can work back and forth and intensify particular areas that need more contrast. However, save your darkest and lightest values for later!

## STEP 5: *Paint the Drake*

Transfer the more important details back onto the painting. Start work on the drake first. Work with thin washes and increasing value changes. Work with darker values and then go back over the bird with lighter values. The paint will become more opaque and solid as you build up the duck's texture. Keep in mind the direction of the main source of light, in this case the upper right of the picture.

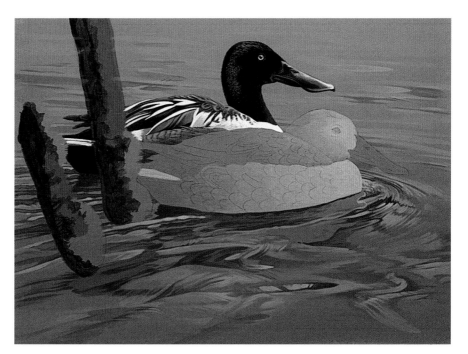

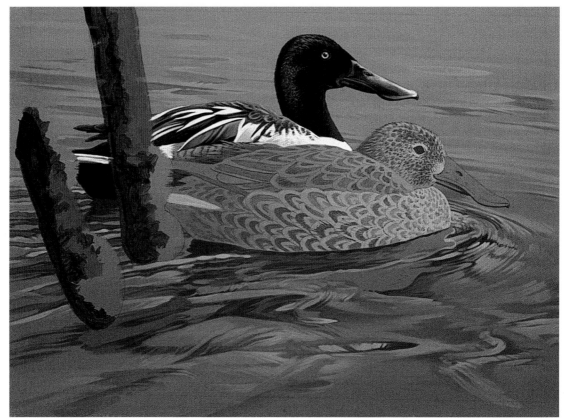

## STEP 6: *Paint the Hen*

The hen is larger and has a more intricate feather pattern than the drake. Use a medium value for the feather markings and wash in the patterns and shadows of the hen (primarily Yellow Ochre and then the violet, orange, yellow and Burnt Umber added to adjust the value). You may have to build these areas up with this value. It provides a good base to paint on and helps to convey the details and three-dimensional look to the duck. The same paint value can be used to accent the bill at this stage too.

## STEP 7: *Refine the Hen*

Use darker values to sculpt the hen and her feathers. Visualize the feathers as curved slightly both down the feather vane and on each side. Use the darker values to indicate shadows on the lower side of the feathers and also to suggest feather breaks, where the feather has separated. Keep values darker in the shadow areas, such as the lower part of the hen and back toward her tail.

## STEP 8: *Add the Light and Develop the Cattails*

Add light to the hen's feathers to make her look even more realistic, lightening the value with white tinted with dabs of Cadmium Orange, Cadmium Yellow Medium, Yellow Ochre, or Burnt Umber and Quinacridone Violet to keep the slightly reddish tan look to these feather edges. Build with washes as you work toward the source of light. The feathers catch more light as they curve around the hen's body and angle toward the sun. Wash some green into the speculum above the tail on the wing. Don't forget her reflection as well!

Then start on the light side of the cattail heads and apply light values that suggest the fine texture there. Wash color over the transition area between the shadow side and the sunlit side. This allows the lighter detail to come through. You may have to work back and forth with the light and dark colors to get the texture defined.

## STEP 9: *Final Touches*

Continue building the cattails using a medium value to paint the leaves and stalks, then develop the shadows and highlights. The areas of the cattail heads that have opened will take several coats of paint to build up the soft white look. Remember the shadows and light even in this small area.

Some shadow areas of the hen need to be darkened slightly, but keep them lighter than the darkest part of the cattails. The light reflections on the water could be enhanced for more emphasis too. Several light washes should build that up quickly.

Looking this painting over, the background needs more work; it's too dark. Use some light blue washes on the water surface reflections to lighten them and provide more contrast with the ducks.

Also, the hen needs more light across her back and the top of the side pocket.

Finished!

*Northern Shovelers*
Acrylic on panel
7" × 10" (18cm × 25cm)
Collection of the artist

# Placing Mallards Into a Detailed Background

ACRYLIC

Placing birds into a background can be a real stumbling block. How do you decide what type of background it should be? Should it be a marsh, a lake, a shoreline? How about the sky? Should it be a dark sky with lots of clouds, or maybe a bright, clear blue? What season should it be? Spring or fall would be good because the birds could have their bright breeding plumage. Should there be foreground vegetation, and if so, how big and close should it be?

The questions go on and on. Some of these concerns are minor and some are big issues. They all affect the overall look of the painting.

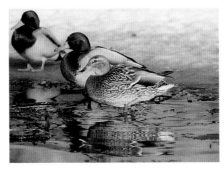

The photo of these mallards was taken at a city park.

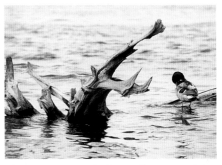

This stump was in the bay at the same park. It has a good form, but the angle needs to be changed if the ducks are to perch on top of it.

MATERIALS

**Surface**
Solid Ground polymer panel

**Paint**
Burnt Umber
Cadmium Orange
Cadmium Yellow
    Medium
Cerulean Blue
Quinacridone Violet
Titanium White
Ultramarine Blue
Yellow Ochre

**Brushes**
no. 1 and no. 2
    round sables

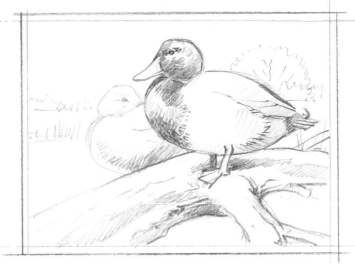

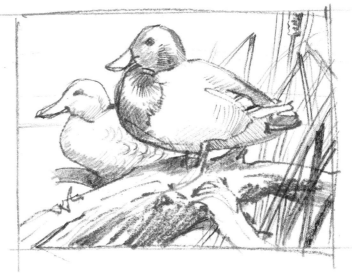

*Make Use of Thumbnail Sketches*
Use thumbnail sketches to help you decide which position you want your subjects to take. Should the hen be shown sleeping? Should both ducks be alert? What sort of foliage should surround the pair? Preliminary work is always helpful and a time-saver for the actual painting process that comes later.

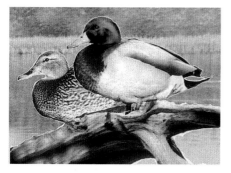
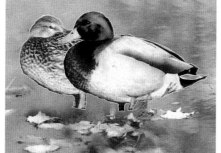

*Using a Computer as a Tool*
Try scanning your reference photos into your computer. Pair the hen and drake together in the proper scale. You can then experiment by placing the ducks on different photos for background ideas. Although, sometimes, instead of helping make a choice, all this playing around results in even more options!

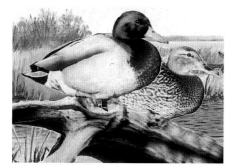
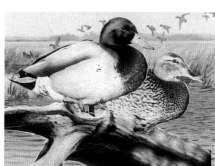

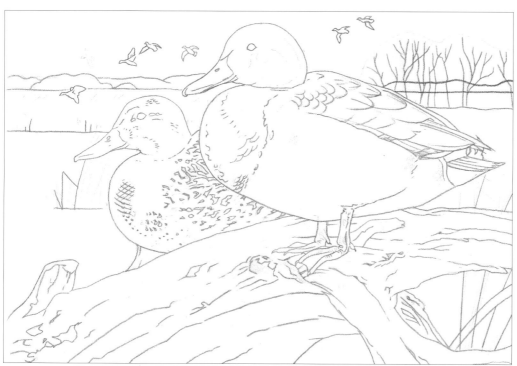

## STEP 1: *Layout Drawing*

Once you've decided on your composition, create your layout drawing. I like the bottom, right computer composition. Flipping the duck pair to face the opposite direction helps tie the composition together. The birds flying in the background here help give this composition depth and energy. Showing the mallard pair close-up showcases the birds and their markings.

When you've finished your drawing, transfer the basic outline of the ducks and background to your painting surface.

## STEP 2: *Start the Background*

It helps to start with the background, so that as you work on the closer objects, they can overlap what is behind them. Begin with several thin layers of a light value and cover the entire image area. This will be your base paint. Then use thin paint and color values that represent the middle tone of your background. In the sky, paint the blue areas around the clouds. Leave the basecoat as the cloud color for now.

## STEP 3: *Develop the Background*

The tree branches in the background serve as a guide as you apply the foliage. Paint several values of blue in the water, using a wet-on-wet technique. You have to blend them quickly before they start to dry.

Working with both darker and lighter values, finish the background. Keep the muted values in mind, so you do not make any areas too dark.

You can always make adjustments later.

Use the same approach on the stump. Begin with a medium value and then use some darker values to indicate form and shadows. Work from the middle values, then on to slightly darker values, and build the forms with slightly lighter values. Increase the contrast gradually and add more color intensity as you go.

## Step 4: *Finish Stump and Start Hen*

Finish painting in the details of the stump, giving it texture and developing the shadow.

Paint the base color/value of the hen mallard with a mixture of white with Yellow Ochre and a few dabs of Burnt Umber, Cadmium Orange and Cadmium Yellow Medium. If this mixture is too yellow, add a little bit of Cerulean Blue and more Burnt Umber. It takes several coats of thin paint to build up an opaque, solid basecoat.

## Step 5: *Develop the Hen*

Refer back to your drawing to transfer the major feather patterns onto the hen. Paint these markings with dark values, including thin washes. The direction of these start to suggest the form of the body. Apply a basecoat to the hen's bill at this time and add some details.

## Step 6: *Finish the Hen*

Continue on the hen with lighter and darker values, but also use some washes of color in areas like the breast and head. These will increase the color intensity. Using subtle washes, you can slowly build color and shadows. Both will enhance the body shape. The last light and dark colors are equally valuable for final shadows and highlights. Still try to hold back these values a bit, so the drake, which is the most predominant and closest object in the composition, will have the darkest and lightest values. The drake's coloring should push the hen back and behind him in the picture plane.

## STEP 7: *Start the Drake*

Block in the colors for the drake. Look for the medium-value color that best represents that color area. Use slightly darker values on both the breast and side pocket areas. This is to suggest shadows and feathers.

High on the drake's back, use the same values to draw some of the feathers to paint in that area. These light washes and subtle value changes are good ways to draw with the paint. They will not smear on your panel like the graphite from a transfer sheet or a pencil sketch over the paint. And, with only that subtle change, you can paint over them easily to either correct or enhance them.

## STEP 8: *Develop the Drake*

Use your darker values to paint with here. The shadows and quite a bit of detail can be established first this way. It is a subtle way to make changes and build them up, making corrections as you go.

However, when you're ready to start painting the drake's bill, switch to lighter values.

## STEP 9: *Finish the Drake*

Continue the process of working back and forth with lighter and darker colors to develop the drake. Add lighter values where the sun hits the ducks and emphasizes their form. Don't just add white to these sunlit areas, add Yellow Ochre, Burnt Umber, Cadmium Orange, or some red to keep them warm and lively.

## STEP 10: *Add Final Details*

The back, feet and tail area are now blocked in. Just as with all the other objects in the painting, continue the process of working back and forth with lighter and darker colors. The lighter values are where the sun hits the duck and emphasizes form, adding a more three-dimensional effect. To make these lighter, sunny values, add some Yellow Ochre, Burnt Umber, Cadmium Orange or red to your white to keep the color warm.

*Mallards*
(2000 Michigan Waterfowl Stamp)
Acrylic on panel
7" × 10" (18cm × 25cm)
Courtesy of the Michigan Duck
Hunters Association

# gallery

*Green-Winged Teal*
Acrylic on panel
7" × 10" (18cm × 25cm)
The Lang Collection

*Morning Light*
(Barrow's goldeneye)
Acrylic on panel
7" × 10" (18cm × 25cm)
Collection of the artist

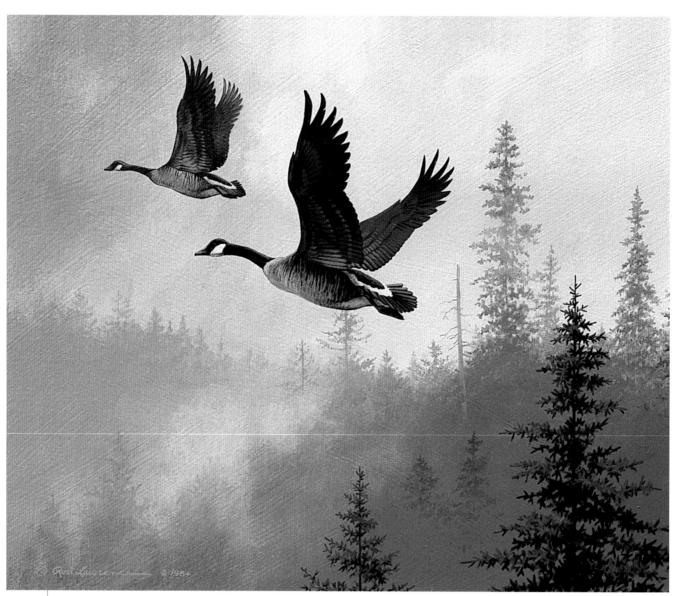

*Northwest Flight*
(Canada geese)
Acrylic on panel
8" × 10" (20cm × 25cm)
Private collection

*Perfect Pintails*
(Hamilton Collection Collector Plate,
North American Ducks)
Acrylic on panel
10" (25cm) circle
Private collection

# Recommended Reading

Listed at right are some books that I recommend for information and reference concerning the wildlife mentioned in this book. In addition to my first book, which is listed here, check out the other art books published by North Light Books. They are excellent and will be very helpful to you. Even if a book is not about your preferred medium, approach it with an open mind. It may have some great tips and useful information. You might even discover the joy of working with other mediums!

Bellrose, Frank C. *Ducks, Geese and Swans of North America*. Harrisburg, PA: Stackpole Books, 1980.

Burk, Bruce. *Complete Waterfowl Studies (Series)*. Exton, PA: Schiffer Press, 1984.

Harrison, Colin with Howard Loxton. *The Bird: Master of Flight*. Hauppauge, NY: Barron's , 1993.

Lawrence, Rod. *Painting Wildlife Textures Step by Step*. Cincinnati: North Light Books, 1997.

Mayer, Ralph. *The Artist's Handbook of Materials and Techniques*. New York: Viking, 1991.

Netherton, John. *At the Water's Edge: Wading Birds of North America*. Stillwater, MN: Voyageur Press, 1998.

Peterson, Roger Tory. *The Peterson Field Guide Series*. Boston: Houghton Mifflin Company, 1980.

Todd, Frank S. *Waterfowl: Ducks, Geese, and Swans of the World*. San Diego: Harcourt Brace Jovanovich, 1979.

Williams, Winston. *Waterbirds of the Northeast*. Tampa, FL: World Publications, 1992.

# conclusion

In the course of this book, I have tried to show you my approach to painting. Although this book is limited to just some of the many wading birds and waterfowl, you can apply this same approach to all your artwork.

I have tried to show you what I look for, what I see, and how I paint wildlife. I always find it enlightening to see what motivates other artists. What is their method of painting? We can learn so much from each other. But it is up to each of us to see with our own eyes, to try to understand what motivates us. Don't limit yourself by what I or other artists do. I urge you to explore other artists, other forms of art, different techniques. You can do this through books, videos, workshops, local art groups, art shows, museums, and so much more.

If you are going to paint wildlife, learn about those species you want to paint. Get out in nature and experience as much as you can. You need to observe the natural world, but you also need to understand it. Think of it as watching a basketball game: It is so much more enjoyable if you understand the rules and know some of the players!

If you don't get discouraged and challenged by your art, then maybe you are not stretching yourself to do more. If it was easy and every painting that flowed from our brushes was a masterpiece, would we still want to paint? Don't become stagnant. Explore all the artistic means of expression that interest you. Grow, but don't grow up. It's good to still have that attitude of a child who wants to get out a box of crayons, a blank piece of paper and just have fun. I think creating artwork is a lifelong objective. I could paint for a hundred years and still be learning something every day. Isn't it exciting to think that there is that much out there to discover! Respect yourself and your artwork. Keep painting!

*Wood Duck*
Acrylic
3" × 4½" (8cm × 11cm)
(shown actual size)
Leigh Yawkey Woodson Art Museum
Miniature Collection

# index

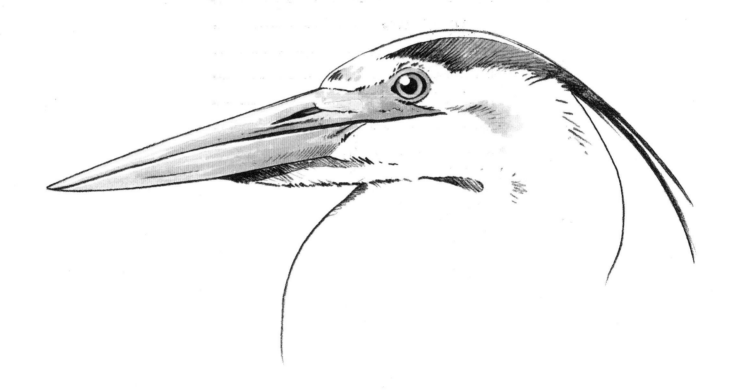